WYETH PEOPLE

WYETH PEOPLE

GENE LOGSDON

Swallow Press / Ohio University Press
Athens

Swallow Press / Ohio University Press, Athens, Ohio 45701

Ohio University Press books are printed on acid-free paper ⊗ ™

11 10 09 08 07 06 05 04 03 5 4 3 2 1

Library of Congress Cataloging-in-Publication Data

Logsdon, Gene.
 Wyeth people / Gene Logsdon.
 p. cm.
 Originally published: Dallas, Tex. : Taylor Pub. Co., c1988.
 Includes index.
 ISBN 0-8040-1062-5 (pbk.: alk. paper)
 1. Wyeth, Andrew. 1917– 2. Painters—United States—Biography. 3. Wyeth,
Andrew., 1917– Friends and associates. I. Title.

ND237.W93L6 2003
759.13—dc21

 2003050564

Dedicated to my mother
Catherine (Rall) Logsdon
whom Andrew Wyeth painted many times
though he never saw her.

CONTENTS

Whenever I see a current photo of Andrew Wyeth, I do a double-take, wondering for an instant who this older man is, masquerading as my hero. I of course go through the same quick thought process when I look in the mirror. It has been twenty years since I had my last impromptu "audience" with the man who, without trying or intending to do so, became my guru. I will forever see him as he was then, possessed of that quicksilver youthfulness that imparts an aura of permanent zest and vigor to maturity. He was sitting at a restaurant table, and he was not laughing as he did at our first meeting. He turned to me and asked that I not write any more about his models because when I did, it was extremely difficult for him to paint them again— somehow I destroyed the special relationship he had developed with his subjects. I was embarrassed. Ashamed really, because I understood what he meant. A book I thought would please him was really a pain in his neck. I was part of the gallery that would love him to death if it could.

But if I admired him then, I am in awe of him now, from the distance of many miles and nearly twenty years. I watch for his appearances on television; I pore over the books of his paintings; I read the clippings people send me from all over. I can appreciate now how age saps one's creative endurance.

And yet he goes on, as productive as ever. And not simply productive, but still probing, still searching for new ideas, new subjects, new approaches, testing, experimenting, venturing into unexplored possibilities, seeking perfection in his art. And painting not just easy stuff, but the compassion, pain, joy, and sexuality arising directly out of the human psyche. I continue to be his unabashed admirer and do not mind when knowledgeable people call me naive.

Aside from my hero worship for Wyeth, much has changed in the 20 years since I wrote this book. Most of the people in it, his models, have passed away or drifted beyond my ken. I in turn have drifted back to my home country in Ohio where with my family, I live strikingly like Forrest Wall and Karl Kuerner did, the subjects of Wyeth paintings who inspired me as much or more than Wyeth did himself. In one sense, this book is a plan, a blueprint of what my life would become after I wrote it. Words made flesh. In writing about Wyeth's models, and through them, searching for glimpses of the artist himself, what I really found was my own identity. And, I believe, a sense of the unique American spirit.

I was never privileged to develop a personal acquaintenceship with Andrew Wyeth, and now I believe that was a blessing in disguise. What I sought from him, what drove me with such compulsion to know him better, was not his particular individuality. Nor was it, I think now, even his art, as such. Oh, I loved his paintings from the very start, but I think I would have simply held his work in high regard as I did Edward Hopper's and let it go at that. Paintings I liked—for what reason I knew not, nor really cared. But what goaded my interest in Wyeth was an interview in the old *Life* magazine by Richard Meryman, in my opinion one of the only good things ever written about the man. That interview helped me understand a little better the wellsprings of

artistic creativity, a subject of consuming interest to me then and now. I was at the beginning of my professional writing career, confused and uncertain about what I should actually try to accomplish by lining up letters on a piece of paper. But what Meryman quoted Wyeth as saying made sense to me as no teacher, theory, or book had ever done before. I wanted to know more, and when I could not get it from the artist himself, I tried to get it from his subjects. And I have continued to search for it ever since.

What I have concluded may sound silly, or for all I know, may already be written down by someone else. But it seems to me the best thing I could add to this book, as an amplification of why and what I wrote 20 years ago.

I believe artistic creativity exists in the same way a thought exists, or love, which is to say that it arises in that mysterious realm of the human animal where body and spirit intersect. Artistic creativity is not the same thing as intelligence, or craftsmanship necessarily, or shrewdness, or aptitude for some manifestation of artistry, as for example, playing the violin. A musician may play with tremendous technical brilliance and still not be creative. Artistic creativity involves an earthiness, an emotionality joining to spirit or intellect. A connection between body and something outside the body that affects its soul. In the act of artistic creativity this "connection" pulsates between people, or between people and other animate or inanimate things.

How can this be? Physicists study a phenomenon they call entrainment or "mode-locking." Mode-locking was first observed two centuries ago by the Dutch physicist, Christian Huygens, in two clocks hanging on the wall. Their pendulums were swinging in perfect synchronization, which Huygens knew should not have been possible because no two clocks, especially then, could be that accurate. Science was

eventually able to demonstrate that vibrations transmitted through the clock bodies and the wall caused the pendulums to lock into oscillating unison. Since then mode-locking has been found to be the cause of many natural and mechanical processes including keeping the same side of the moon always to the earth. Play the note, A, loud enough near, but not on, a violin and the A string will hum in sympathetic vibration. Electronics is full of incidences of mode-locking, which is why a radio receiver can be locked in on signals even when there are small fluctuations in their frequency. The poet, Wendell Berry, addressing this subject, writes in *Standing by Words* (North Point Press, 1983, p. 76,) that mud dauber wasps hum while building their nests because the humming sets up a vibration that makes the mud easier to work, "thus mastering their material by a kind of song. Perhaps the hum of the mud dauber only activates that anciently perceived likeness between all creatures and the earth of which they are made. For as common wisdom holds, like *speaks* to like."

The essence of art in my opinion is just that: "Like speaking to like." James Gleick, in his book *Chaos: Making A New Science* points out that "mode-locking accounts for the ability of groups of oscillators, *including biological oscillators, like heart cells and nerve cells,* to work in synchronization." It is my belief that in the depth of the human psyche where ideas are abstracted from reality, some process similar to mode-locking is at work in the act of artistic creativity. Sympathetic vibrations flow between Andrew Wyeth and Helga Testorf, or Andrew Wyeth and Forrest Wall. In the act of painting, painter and model vibrate in unison. So many remarks Wyeth made in his interview with Meryman, seem to suggest that supposition. ". . . he [Ralph Cline] came by and bent over—and that face—that stayed with me—and at his saw-mill, the way he would reach in with his hand and pull up the

logs. Honestly I don't know what it was—something very elusive made me ask him to pose." Again: "And he [Spud Murphy] turned a little, and I remember seeing his back dark, and the light on his face. And I remember being terribly excited It was a very queer thing." Or again, "Now I just about lived with Ralph Cline for a month and a half—almost became Ralph, Betsy tells me." Or again: ". . . Ralph turned out to be the kind of character I love to dream about. So it was partly painted before I ever painted it. That man is partly me." More that just metaphorically, Wyeth and Cline mode-locked in physiological unison.

If what I'm suggesting is true, then the subject of a painting, be it a tree, a person, a cow, whatever, is as much a part of the creative process as the artist himself—may sometimes be the greater part of it. Wyeth tried to use Helga's daughter for a model but the results were not satisfactory. Might not that be because the flow of sympathetic vibrations necessary for artistic creativity could not, for reasons unknown, flow between them? Could it possibly be that Helga but not her daughter hummed the right note to vibrate Wyeth's painterly strings?

But this odd notion of artistic creativity is not confined, in my opinion, to artist and model in isolation. (Or writer and interviewee.) The subsequent viewer also has critical involvement. Again a Wyeth quote from Meryman's interview: ". . . in fifteen minutes I had a drawing just on the corner of the pad. It was just a fleeting expression of his—I don't remember drawing it—couldn't do it again. I was moved and everything was spontaneous. I brought it home . . . and hid it behind the refrigerator. I was terribly excited about it. After supper . . . I hauled my pad out. I flashed the drawing at Betsy for a second and then took it away. If a person has time to analyze too much, talks it out—you deaden the thing, freeze it. But Betsy's remarkable because she has an

intuition that catches what I'm after. . . . All she said this time was 'My God, Andy, just terrific; just terrific.' If she'd been dull and said 'oh well'—it would have killed it right there." What finally makes the painting great is when the sympathetic vibrations are so strong they mode-lock the audience too. The final proof of the creativity is its acceptance by the viewer, and the more universal the acceptance the more proof of the work's greatness.

I doubt Andrew Wyeth's enormous popularity in the face of much negative criticism from the arty world can be explained solely in these physiological terms. Because of his origin, the setting for his painting is rural America, and so it appeals easily to one of the largest definable groups in the world: those people with roots, real or desired, in rural society. As urban and urbane as the world has become, even the most advanced industrial nations are steeped in rural tradition. That is why Wyeth appeals to the Japanese, a nation still with 800,000 farmers and two generations of factory workers barely removed from farming. Americans are only a century away from the time when every other citizen was a product of traditional rural life and even now surely a fourth of us are tied to the land by actuality, family memory, or sentiment. Enhancing that cultural appeal, Wyeth came to the fore at a particularly crucial time in rural history: when those rural roots were perceived to be vanishing like most of their physical attributes certainly were. Millions of people were therefore first attracted to Wyeth's work superficially, in mourning for a lost heritage. Their attention arrested, they became aware of something else flowing in and out of the paintings.

This rurality is what makes so much of the arty world spurn Wyeth. The world he paints is foreign to them. They do not look past the barns and fences and almost ghostly faces to feel more fundamental vibrations. Perhaps they cannot.

They say Wyeth paints the past, because to them the rural world *is* of the past. So far as I know, Wyeth has painted only living people, only actual scenes more real to more people than satellites tumbling in space, so it can hardly be "the past." Even Helga, which the arty like to see as a departure from Wyeth's "wagon wheel" days, is consummately rural. (One of the most pitiful prejudices of urban society is that one must go to the city to appreciate the finer sensual and sexual delights of life.) But you cannot look at her, even stark naked in stark surroundings and imagine her as a city person, just as you cannot look at a Hopper nude and imagine a country person. Far from renouncing his rural countryside with Helga, Wyeth is reaffirming its constant regeneration.

Wyeth paints a *passing* scene of course. What scene is not passing? The old rural scene is passing, and whether it will continue to regenerate more Forrest Walls, and Siri Ericksons and Helga Testorfs and families like mine is a question not easily answered. I ended this book two decades ago with my sister saying that we peasants, we rural people, always endure. In the intervening years I have sometimes doubted that statement because of the profound change in the commercial family farm. But behold, here my sisters and brother all stand steadfast with their families, forging a new landscape of rural life. I and others have come back from the cities with our families to join them, to take up hoes and hive scrapers again—taking up the stewardship of traditional rural virtues as old and indestructible as mankind. Our houses are newer than Karl Kuerner's, our outlook more worldly than Adam Johnson's, our clothes more fashionable than Christina Olson's. But underneath, stripped naked to the soul, we are Helga, and we endure.

Gene Logsdon

IN SEARCH OF ANDREW WYETH

Although I have dogged Andrew Wyeth's boot tracks over the hills of eastern Pennsylvania and along the coastline of Maine to find reasons for his eminence and popularity, I believe that the explanation, or at least part of it, must begin back on an Ohio farm where in the early fifties my sisters and I first saw a Wyeth print.

Our family lived during those gossamer days of Early Eisenhower in a very small world. The sun came up from behind Fred McCarthy's woods and set on the other side of Adrian Rall's sawmill. In our frame of reference, South meant Fred Schmidt's eighty acres, turn right at the second orchard, and North was anything past the walnut tree up the pike. We were not at all insulated from the rest of the country, but beyond these boundaries very little really seemed to matter. There simply wasn't time enough to become "involved," as it is the fashion to say now, beyond our fence lines.

Our farm was an endless series of crises that brooked no delay in solving: newborn calves that would not suckle and bull thistles that would not die; cows that must be milked and hogs that had to be fed; corn that needed rain, but not too much, and wheat that needed dry weather, but only for a

while. Yet there was an easy joy to the hustle, the cool shade between corn rows and the red surprise of wild strawberries on the way back to dinner. Noon dinner. It was an earthy, inward-turning existence, with one exception.

A painter who lived in a faraway place called Chadds Ford was our hero.

Andrew Wyeth put on canvas the things we thought no one else but us ever saw: a corn knife left in a barn corner; a piece of horse harness hanging from a cobwebby wall. He painted a bull the way we saw a bull—a particular animal not quite like any other. He understood corn the way we did, we who cut, shocked, shredded, and husked it and lived off the income it provided. He could render a bent and pitted enamelware pot upside down on a fence post so real that we knew that he knew there was a wasp nest inside it.

But more than simply catching the uniqueness of an individual reality, he seemed to realize that all these objects, the berry buckets and cider barrels and hay lofts and cooling sheds—the trappings of our lives—had wider meaning. Apparently he knew that a kid on a farm could feel tragedy and abandonment just by watching the wind play through the tattered, frayed sleeves of last summer's scarecrow, or by finding a dead blackbird in a winter cornfield.

That we discovered Wyeth in the early 1950s was no great thing. It was Wyeth who was making the important discovery, whether he knew it or not. His work—somewhat unconsciously perhaps—said something to and for the legions of Americans who lived beyond the world of big newspapers, national television, and slick magazines.

But we Logsdons didn't understand that yet. We considered our relation to Wyeth unique and personal. Only a few people, we thought, would bother to give him a second look. Who besides us cared about cattle troughs?

Time passed and we learned better. One of my sisters, Jenny, and her husband visited Chadds Ford on their honeymoon. Jenny figured—and rightly so, as it has turned out—that she would probably never get another chance to go there. She persuaded Jim to drive up to the Wyeth home and knock on the door, being too proud and shy herself even to knock on the doors of people she knew well.

"I stayed in the car," she said later, "but I honestly thought that if we could tell Andrew [mentally, we had been on a first-name basis with him for a long time] how we felt about him, he'd just throw open the house and we could talk about old barns all afternoon."

Betsy, Wyeth's wife, answered the door.

"She knew I was just a curious passerby," says Jim, "but she managed to tell me in such a gracious way that her husband wasn't home and for all practical purposes wasn't going to be home, that I felt ashamed, not rebuffed. Without actually saying it, she let me know I was only about the twentieth tourist to drop in that week."

"But I did see him anyway," Jenny said. "While Jim was at the door, Andrew came wheeling into the drive in a truck. Spotting us, he spun on around another building and disappeared. I felt just like Moses in the Bible when he asked to see God and got only a glimpse of His backside."

It slowly dawned on us that if an eager Ohio farm family felt compelled to invite themselves to Wyeth's home, probably half the eastern seaboard was trying to get its foot in his door.

But it perplexed us even more to discover that though so many tried for Wyeth's attention, there were others who held his work in low esteem. Teresa, another sister of mine, found this out. She saved her money after high school, painted in her spare time, and eventually made application to an art

school in Cleveland. When she presented her homespun port-folio to an admissions official, he glanced at it briefly.

"You like Andrew Wyeth, don't you?" he asked.

Teresa beamed, surprised beyond her wildest dreams of glory. "Yes, *sir,* I certainly do," she replied.

The man sniffed. "Well, it's all right to start out that way, I suppose."

Soon after that, I went to work in Philadelphia, bought a home in the semi-rural "Wyeth country" of southeastern Pennsylvania, and continued on the route that led, by devious back roads, finally to Wyeth himself.

Living and working in the same type of surroundings that Wyeth did, I learned more of the taste and feel of a Wyeth painting. I began to sense that there was something about the way an old stone barn lies against an autumn-brown pasture in this corner of Pennsylvania that was different. It was not a difference that words could define, not one that could stand the press of close study; but it was there, and Wyeth knew it was there.

Viewing his work on exhibition in Philadelphia, I tried to understand what the art world is inclined to call the "power" of an original painting. And reading every word about Wyeth that I could find, I began to get a feeling about him, from his own quoted words, that was infinitely more refresh-ing than the studious discussions of art that I had been ex-posed to before. I wasn't qualified to write the words of art criticism. All I knew about egg tempera, the medium Wyeth often works in, was that his dog Rattler used to get to eat the egg whites left over.

To produce good art, Wyeth said, you don't have to travel all over the world to "broaden" yourself. Uneducated peo-ple, he hinted, just might understand art better than those who had creativity self-consciously taught out of their sys-

tems in school. And he wasn't afraid to mention the museum visitor who walks right past a painting until it's tagged with a high price.

He talked about creativity in a way I understood:

"You see, I don't say, 'Well, now I'm going to go out and find something to paint.' To hell with that. You might just as well stay at home and have a good glass of whiskey. . . .

"I get strange, my hair rises on the back of my head when I begin to sense something. And nothing can stop me. I can't go anywhere, do anything, but grab that thing.

"I wish I could paint without me existing—that just my hands were there. I wish I could be Rattler running through these woods, looking up at the branches in the sunlight, the leaves falling down on top of him. When I'm alone in the woods, across these fields, I forget all about myself. I cease to exist."*

Slowly, almost inexorably it seemed, my trail wound its way to Wyeth's very own haunts. I began to meet the people he painted. Over and over again, in talking with them, I'd hear the phrase "Andy and me." I was struck by the conscious and unconscious closeness between painter and painted—in almost a physical way, Wyeth was a part of these people and they were a part of him.

I learned that some of the people he painted, like Christina Olson and Henry Teel, had already died. With them was lost, I felt sure, precious information about the fabric of an artist— and of a culture that prized him so highly. There evolved in my mind the idea of writing about Wyeth through the eyes of the people he considered important enough to paint, people possessing a power to move his creativity to action. Might they tell me more about Wyeth than he could himself?

* Richard Meryman, "Andrew Wyeth: An Interview," *Life*, May 14, 1965, pp. 93–122.

LUNCH WITH WYETH

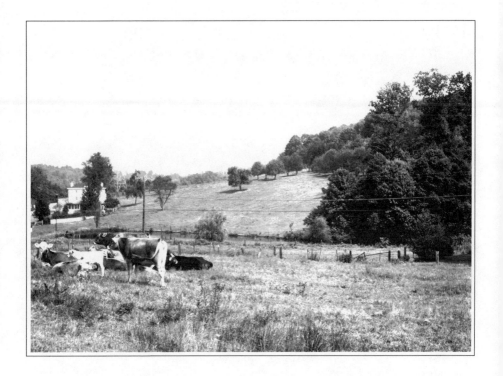

Chadds Ford is a little village in southeastern Pennsylvania that preserves what urban people call rural charm, even though the countryside around it is in danger of being subdivisioned out of recognition. The hill that Wyeth painted for *Winter 1946* is now pockmarked with houses and scarred by asphalt driveways. But I didn't know about that hill the first time I visited the village, nor was I aware of the subdivisions. I was strictly tourist class. I saw only the intersection of Routes 1 and 100, a couple of restaurants and a gas station. And the only reason I was there at all at noon on a February Tuesday was that I was writing an article about Ira Hicks' dairy farm not far away. Not even in the rear recesses of my mind did I suspect that the right time and the right place had arrived for a meeting with Andrew Wyeth.

I stopped at the Sunoco station at the heart of the village and said the tourist thing.

"Does Andrew Wyeth live around here?"

The attendant putting gas in my car kept staring at the pump. I didn't think he heard. Finally he heaved a long-suffering sigh.

11

"Up that road a ways," he said, nodding toward Route 100. The words came out as if a drop of gasoline had splashed into his mouth. I paid him with extra grace, but he volunteered no more information.

Across the road was a diner—Hank's place. I sat down on one of the dozen or so stools around the masonite counter, ordered a hamburger, and asked the old man next to me—almost whispered in the small, silent room—if he knew Andrew Wyeth. More silence. I tried to describe Wyeth quickly: "You know, the man who paints barns and things." "No, I don't," he said finally, between bites of his sandwich. "Wish I did. Mine needs paintin'."

I stared at my coffee cup. If others had heard, they gave no indication. Everyone who entered greeted those who were eating, except me, of course. A girl came in, waving an envelope at the cook, who turned out to be Hank Shupe, the owner. "Hey, Dad, the pictures came." Hank and Mrs. Shupe, appearing from the back room, went to the counter for a look. The photographs were of a baby belonging to their son, who lived in Tennessee, and Hank passed them around for everyone to see. I looked too. We all agreed that the one of the baby peeking out from under a blanket was the best picture.

I tried to strike up a conversation. "Do you know any of the old stories about a Revolutionary War hero called Sandy Flash?" Chadds Ford and the whole Brandywine Valley absolutely seep with history and, as I suspected, my question was not considered peculiar.

Hank shook his head. He had heard the name Sandy Flash all right but he had no time for legends.

"You should have known Cris Sanderson," one fellow down the counter volunteered. "Cris knew all that stuff." Hank nodded. "Yeah. Died last year."

I took a deep breath. I was going to broach the subject of Andrew Wyeth loud enough for all to hear, and I was afraid I was changing subjects too drastically. What I didn't know then was that Sanderson had been Wyeth's private tutor once, that they had been lifelong friends, and that they belonged together in Chadds Ford like bread and butter.

"You could make *this* place pretty historical," I allowed, trying to sound casual, "if you could get the Wyeths to eat here once in a while."

Laughter erupted above the sizzle of frying hamburgers.

"Once and a while!" Hank exclaimed. "They're down here all the time now. Practically had to kick Jamie out of here last night so I could close up." He looked at the clock on the wall. "He'll be in here in a minute. Old man and lady too. Andy gets a kick out of coming in here."

I ordered another hamburger. I'd eat forty-seven of them and die of gastritis waiting for Wyeth, if I had to.

As if on cue, Wyeth walked in. His long arms dangled loosely from the sleeves of an old jacket, and an ear-to-ear grin cracked his face. Completely devoid of his much publicized shyness and the tense nervousness he showed on television, he looked for all the world like a happy-go-lucky truckdriver who had just cashed his paycheck.

"No soup today," Hank sang out as Wyeth sat down.

"Okay, I'll take a hamburger then," he replied. He was joking with the others, and they were treating him like an equal, this man who had sat next to God in my earlier days.

Mrs. Shupe wiped her hands on her apron and took the photographs of her granddaughter over to him.

"Which one do you like the best?" she asked. Wyeth looked the pictures over carefully, enjoying them almost as much as the family had. Finally he settled on the photo with the baby

peeking out from under the blanket. "That's the one we all like, too," said Hank. The artist seemed pleased that he had picked the correct snapshot.

Someone asked where Jamie was—Wyeth's son, who some people think is a better artist than the father. "In disgrace today," Wyeth said. "He got a ticket for speeding last night."

A young, smartly dressed Negro came in, said, "Hi, Andy," and sat down beside him to talk. At every lull in the conversation, Andrew would twist around, look out the window, and say loudly: "What's keeping that woman?" But no one paid any attention to his question.

It was now or never, I decided. But what to say? I would at least seem consistent if I stuck with legends. "Hey, Andy, ever hear of a Revolutionary War outlaw named Sandy Flash?" He looked at me quickly as soon as I said "Andy," and all through my question, which seemed to me to string out forever, I could tell he was trying to place me, as if I were a neighbor he was supposed to know. The silence in the diner made my stomach cringe, but there was no snobbishness in Wyeth's face.

Finally, he said that of course he knew about Sandy Flash— "our Robin Hood," he called him. I wonder even now if there was anything else that would have turned him to me so easily. Bless you, old Sandy Flash.

He responded the way the others had. Did I know Cris Sanderson? He knew all about Sandy Flash. Then he said I should visit the Bayard Taylor Library in Kennett Square for books about the outlaw.

But I told him I was not interested so much in the history books, but more in the folklore, where ordinary people kept their own special history and passed it on orally to their children. He caught that immediately, and warmed to the notion. "Of course," he said. "That could be more interest-

ing." I thought we were going to understand each other right then. I picked up my cold hamburger and coffee, walked to his end of the counter and sat down beside him. It just seemed like the natural thing to do.

He told me there was a lot of folklore about the Revolution still alive around Chadds Ford. "You see, this area can fool you. Not far from the highways and the new housing and the modern factories, you can find people whose memories and way of living run back to another time. But that's the point. It *isn't* another time. It's right here and now, a stone's throw from your four-lane highway and TV-in-every-room motel."

Wyeth kept talking. Didn't ask me my name. Didn't care. It was almost as I had imagined it back in Ohio: two strangers meeting in a foreign land and finding that they not only came from the same town, but dreamed the same dreams.

He remembered that Sandy Flash had been hanged at Castle Rock near Newtown Square. "You ought to take a look in the museum in West Chester. They probably have the noose they hung him with over there." He chuckled at his own joke.

I found myself telling him crazy things—about our little museum back home in Ohio, in which the county preserved for years the empty shotgun cartridges found at the scene of a local murder. Even as I spoke I kept wondering why I was telling him perhaps the most unimportant bit of knowledge I possessed. But he laughed a genuinely hearty laugh and said Ohio must be pretty rough country. That reminded him of Bonnie and Clyde. "A great movie you don't want to miss," he said. He was lumping Oklahoma and Texas with Ohio, as many Easterners do, as if everything west of the Appalachians would fit into a five-gallon bucket.

"I remember when the Barrows' bullet-riddled car was exhibited through the country," he recalled. "I bet there were twenty cars like that being hauled around at the same time."

Then he told me about the fight against pollution on the Brandywine, and how things were better now. "Even the shad are coming back up the creek again," he said.

I tried to get him to talk about the move he had led to save some farmland around Chadds Ford from commercial development. I remembered a newspaper illustration, showing him sitting in a field. The caption quoted him: "I won't get up until the bulldozers go away." And they did go away.

But he wouldn't talk about that. Instead, he reminisced about how he used to go up on his father's place "where there were huge boulders with nicks in them made by musket balls during the Revolution. I used to search around the base of these rocks and find the bullets, too." So I told him stories about finding Indian relics in cornfields. He said he never found any, though he spent a lot of time in cornfields because the wind rustling the leaves was one of his favorite sounds.

It was a good time to bring up his paintings, but I was afraid. Besides, it didn't seem to matter much now. We were just two human beings finding rapport in insignificance.

We talked about waterwheels and gristmills for a while, because he owned one and I wished I did. "We've been restoring ours for ten years now," he said. "You can come down and take a look at it, if you want to." (If I wanted to, he said, as if I might not.)

I looked at his hands. They were long and dirty. Mostly black dirt—charcoal, I think, with red and green paint sticking around the edges of his fingernails.

Just then Andy broke into his big chunky smile. "That woman" he had been expecting was coming through the door.

After you have loved a painting for many years, there is no feeling quite like seeing it come alive before your eyes. Betsy Wyeth, the painter's wife, wearing a hat not unlike the one on her head in *Maga's Daughter*, smiled at her husband. She delivered neither more nor less than Wyeth's picture of her had promised.

I started to get up so she could sit next to him, but she shook her head pleasantly and moved on down to the other end of the diner. Then Andy began to flirt with her across the room. "Tell that good-looking gal down there that the gentleman here will take care of her bill," he said unctuously to Hank. Then he laughed like a child, while Betsy, her eyes sparkling, pretended to ignore him.

"Here's a man who wants to know all about Sandy Flash, Betsy," Andy said. "You know anyone who could tell the old stories about him?" Betsy smiled. She said that Cris Sanderson would have known. I was getting the distinct feeling that, in Chadds Ford, Cris Sanderson was more important than Andrew Wyeth.

The subject of conversation got around to gristmills again. "Our mill wheel weighs eleven tons," Wyeth said, "and it doesn't have more than an inch of side wobble at full speed." Betsy interjected: "Stop by and see it sometime."

"What we intend to do is generate our own electricity," he said with a childlike pride.

"My dad always vowed he was going to do that," I said.

"What's he do?"

"He's an independent cuss who farms because he won't take orders from anyone."

Andy grinned. "That's why he wants to make his own electricity."

"Maybe some farmers and some painters are alike," I said.

I had cut too close. Or else I had reminded him of where he was supposed to be. He got up to leave. Then he turned back, and stuck out his hand. "What's your name?" he asked, sheepishly. I told him. "Why don't you write down your phone number," he suggested to my unbelieving ears. "If I hear anything about Sandy Flash, I'll let you know."

He stuck the piece of paper I wrote on into the pocket of his old jacket. I bet it's still there.

3

THE PAINTER AND THE PAINTED

I had met Andrew Wyeth. And the biological need to meet him—a need that seems to afflict so many people who see his work—turned into another equally irrational compulsion. I must write something about him. The typewriter addict is never content to find a flower in the woods, enjoy it, and go away. He must tell someone else.

But what to write? The magazines had already done Wyeth to death, disinterred the literary bones, gnawed and worried them into the earth again. By the middle 1960s, any magazine that hadn't expressed amazement at Wyeth's rise to fame (or at the price of his paintings) was either asleep in Broken Bow, Nebraska, or looking for a new editor. The *Saturday Evening Post*, in its days of vigor, scored a first victory with the one and only Wyeth cover, an exercise the artist never repeated though each offer from the *Post* went higher up the financial scale.

Such diverse magazines as *Ramparts* (1963), *Maine Digest* (Wyeth was a local boy making good and boosting the tourist trade), *Atlantic* (1964), and *Show* (1965) ran up the flag for Wyeth. "The Wonderful World of Andrew Wyeth," sighed

Woman's Day in an August 1963 piece. "Andy's World," echoed *Time* in December of the same year.

Cosmopolitan, which had dealt itself in earlier with a 1959 feature, came back in 1965 with the touching title: "Andrew Wyeth's Experiment in Forgiveness." The article rehashed all Wyeth's supposed artistic vices and virtues within the framework of an anecdote about the Halloween pranksters who had broken into his studio and vandalized it. When the boys were caught, Wyeth wouldn't press charges, hoping that love and forgiveness would work more improvement than fines or imprisonment. Tune in tomorrow for the next exciting episode. You could almost hear the managing editor's triumphant: "Well, we did it. We got a new slant on that fellow."

Almost all the articles told more about the special style and philosophy of the magazines that printed them than they did about Wyeth. Beyond that, they presented vacuous generalities of art criticism:

Wyeth was a realist, who proved the abstractionists were wrong.

Wyeth was really an abstractionist, who proved the realists were wrong.

Wyeth was, abstractly speaking, a realistic surrealist.

Wyeth was a sentimentalist. Wyeth was not a sentimentalist.

Wyeth was an unsentimental sentimentalist.

Wyeth recorded an age that was dying.

Wyeth recorded a dying that was coming of age.

Wyeth's temperas were the highest form of his expression.

Wyeth's watercolors were the highest form of his expression.

Wyeth's sketches were the highest form of his expression.

Wyeth's doodles, retrieved from the studio floor, were the highest form of his expression.

Wyeth was influenced by his illustrator father, N. C. Wyeth.

Son Jamie was influenced by Wyeth.

Henriette influenced Andy.

Ann influenced Nathaniel.

Peter Hurd influenced Andy.

Wyeth was in the tradition of Hopper, Eakins, Peale, and Winslow Homer.

Wyeth adhered to no school of art at all.

Wyeth was the other side of modern art.

Wyeth was a reactionary.

Wyeth was a reaction.

Run, Shep, run.

Most of the writers and critics were nice to Wyeth. Adverse criticism seldom appeared, even from the avant-garde in modern art. But about 1967, the tide started to go out again. Titles began to appear like: "Andrew Wyeth: An Unsentimental Reappraisal" in *Art in America,* which had recorded favorably every move Wyeth made on his way up to the pinnacle. Another was "Why Wyeth?" in *Saturday Review* in 1968.

Wyeth had become too popular for the comfort of the intellectuals. Loudon Wainwright's editorial in *Life* put it most cleverly when he described the people flocking to Wyeth's exhibits: "It was as if great numbers of people had decided in advance to come and adore a bunch of framed holy relics."

You can share fame in two ways: helping it or fighting it. But one thing in common with all the articles, pro and con, was the inclusion of Wyeth's name in the title.

Popularity brought other kinds of criticism. When a reader of *Art News* saw Wyeth's *Trodden Weed* (the painting Khrushchev liked) he fired off a letter to the editor stating that the painting, which depicts two legs and booted feet, one of which is stepping on a weed in the grass, looked suspiciously like the bottom half of an illustration he had

seen in a magazine. He sent it along and *Art News* duly printed the bottom half of the illustration along with the painting. The two pictures did resemble each other slightly. Hah! Wyeth the Great had been found out.

Wyeth's commonsense answer was typical:

> The idea occurred to me that maybe more paintings other than just the one in the illustration in question would look like *The Trodden Weed,* if we cut off their tops.

But Wyeth said more in the letter to the editor, giving the kind of personal information that he would rarely do later on, which showed characteristics that magazine articles never seemed to grasp.

> Last winter, after undergoing a serious operation [he was in surgery for more than six hours], my first attempts at getting back at my work were to do watercolors from my living room windows of the winter hills outside. Gradually I was able to take short walks, but the weight of carrying my watercolor equipment along with me was too tedious. So frankly I just walked and walked . . . anything to get outside again. My wife had given me for Christmas a pair of boots I shall always prize. They came from the Stanley Arthurs' collections and originally belonged to Howard Pyle. Pyle used the boots often in his illustrations, as did his students, including my father, N. C. Wyeth. When my wife gave them to me, she intended them for costume purposes, but the fit was exact so I wore them on my walks. It's not hard to see how the tempera evolved. My constant watching of my feet and the ground, due to my slow pace, gradually took shape in my mind. The execution of the tempera was painfully slow. I had to work at first with my arm resting in a sling suspended from the ceiling. The painting came to signify to me a close relationship between critical illness and the refusal to accept it—a kind of stalking away.

Wyeth was giving a very uncomplicated reason for his success. He was simply an extraordinarily hard worker, totally dedicated to the way of life he had chosen.

Everything had been said about Wyeth, but in a way very little had been said. What could I do about it? I had no inside track to the now famous family, nor was there a sporting chance of achieving this kind of status.

Then one night, the answer: I was looking at a print of *Young Bull*, a painting Wyeth did on a farm owned by Karl Kuerner. I fell to wondering what a farmer would think about a man painting his bull. Would he think as a farmer might, that the bull was more valuable than the painting? I decided to find out.

Finding Karl Kuerner was how I discovered the hill of *Winter 1946*, where now, instead of the brown grass of the painting, there are new homes. But even so, the discovery became a soul-searing experience.

Almost everyone knows the story of that painting: how the boy running down the hill in a kind of plaintive abandon is a neighbor boy, but figuratively represents Andy himself, grief-stricken and lost over the death of his father. At the foot of that very hill I found the same railroad crossing where N. C. Wyeth was cut down in the prime of his life.

For me there was an even more poignant pain in the realization of what *Winter 1946* meant. Just days before I stood there on that railroad track staring up over the ridge of hills that know Wyeth's footsteps so well, my own mother had died in an accident. And she was every bit as important an influence to me and my work, however insignificant my work might be, as N. C. was to Andrew. I cannot even now look at that Wyeth without embarrassing emotion. Another simple peasant craving after "framed holy relics?"

KARL KUERNER AND HIS BROWN SWISS

You can drive past Karl Kuerner's farm and hardly realize you are in the middle of one of Wyeth's best-known works, *Brown Swiss*, even when you know the painting well. Betsy Wyeth once told me she never takes people to the scenes of her husband's paintings because they were always disappointed. But it was interesting to me to see what Wyeth left out so that he might give more impact to what he left in. The process is similar to that of writing, although it is generally the editor who decides what to delete from a story.

Kuerner's long, tree-edged lane leads from the road, past a pond, over a creek, beside a picturesque old springhouse, to the house. White-plastered, tall, and gaunt the old house stands, out of harmony with the nearby frame-and-shingled barn, which has been repaired only as much as it needs to be and no more.

The man with the shock of white hair who welcomed me was Karl himself. He had aged considerably since Wyeth had painted him (*Karl 1948*). He seemed on the surface such a gentle person, I wondered where Wyeth had found the stubbornness and stern hardness I thought I saw in the picture.

Kuerner invited me in. The first room contained a stove, two chairs, a bare electric bulb overhead. The outside wall was at least two feet thick.

I told him I worked for *Farm Journal*. Since almost every farmer in the country gets it, I figured it was the one thing we might have in common. I told him I liked Brown Swiss cattle and in the same breath that I liked Andrew Wyeth's paintings. Karl nodded, a certain patience in his face. I was one of many, evidently, in the long litany of I-love-Wyeth visitors.

"I am trying to meet as many people Wyeth painted as I can," I explained—as I was to do many times in the days ahead.

He nodded. Without words, his face told me plainly enough: Now you've met me, what should I do? What do you expect of me?

"Has Wyeth painted many pictures on your farm?"

He smiled. "I guess so. I guess about thirty maybe." He led me through the next room and on into the kitchen. The table in front of the window looked familiar. "This is where Wyeth painted *Groundhog Day*, isn't it?" I asked.

He seemed surprised. "You know that? Yes. I got stuck with the tractor out there trying to pull a log away, and when the ground froze up I was coming back to drag it away again, and Andy was here. He looked out the window and saw that log and said, 'Leave it lay there for a while.' He went to painting then right here, and we left him alone. It is very quiet when you are in this house alone. Andy painted the quiet right in the picture."

There was an immense pride in his voice when he talked about Wyeth or, as I found out, about his farm. The two things were somehow bound up with each other. "This place

is, well, like home to Andy. It *is* home, by golly. Andy and me, we've known each other a long time. My land butts up against the Wyeths' over the hill across the road, and the Wyeth kids played around this farm from little on up.

"I raise my Brown Swiss cattle, grow a little oats and hay for them. My son and I work together. We mow grass and trim trees and such for people around here." He chuckled. "I don't farm so hard anymore. More money in taking care of estates."

We moved into the living room. "Here's one of Andy's really early paintings." Karl nodded toward the huge picture on the wall of a man plowing with horses. "That was my team and a hired man years ago.

"Now I want to show you something about Andy Wyeth. You see, when horses are working in the field they sweat plenty, and in the morning and evening when the slant of the sun is right, their hair just glistens. And barn roofs from a distance just seem to be glowing at that time of day. Well, Andy saw that. He saw the light most people wouldn't notice. And he painted it, as you can see. People would say, oh, that ain't the way it really looks, but it *is*. I *know.*"

He pointed at the other wall. "That picture was made by Peter Hurd. He used to keep his horse here. He's the horse-craziest man you ever saw. Anyway, he didn't have any money to pay me, so he gave me that painting.

"Over on that wall is a painting of my springhouse. We found the picture when we were cleaning up an old farmstead. One of N. C. Wyeth's students did it, I'm sure, but we don't know which one. Someone is always painting that springhouse. Except Andy. He'd never paint it. That's what everyone else would do.

"They used this house for a war headquarters during the

Revolution, during the battle of the Brandywine. Washington himself could have been in here. The original part of this house is very old—you can tell by how short the doorframes are. People weren't as tall in those days as now. I rented this place when I first came over from Germany after the war—the First World War. Finally I was able to buy it. Now I'm selling it off a little at a time. But I shouldn't. I sold lots five years ago that I could get twice as much for today.

"Andy spends a lot of time over here, painting. We don't pay him any mind. We let him alone. That's what he needs. To be let alone. To know that we don't care how long he stays, or when he comes, or when he leaves. He could just as well be a rabbit coming and going. That's what he likes.

"Buzzards always interested him, and one day he comes and says he has to have one so he can paint it. So Andy 'n me got the placenta from a newborn calf, put it in the pasture field back there, and set a ring of traps with it. And, by golly, we caught one. So there was Andy out there with that buzzard for days, painting. He wanted to paint it from above, and he had to *see* it. He has to get to know what he paints.

"Like that *Young Bull*. We had to hold that darn thing with a ring in its nose so it would stand still and Andy could paint in every hair like he wanted to. But after a while that darn bull would follow him around like a pet dog. The bull kicked over the paint once and left a smear on the painting, a line like right across the middle. You can see it in the painting. Andy looked at that and decided the bull's touch was just okay. He left it there. How about that now. The only famous painting done partly by a bull. But you see, Andy won't paint cows out in a field. They don't hold still long enough so he can get them right, I guess. There's no Brown Swiss in *Brown Swiss.* "

The whole farm was like a museum of Wyeth paintings cleverly concealed by reality. It was delightful hunting them out.

We went through the barn. I found the cattle trough that became *Spring Fed* on canvas. Even the bucket was there as it was in the painting, but the background was now an accumulation of junk and cobwebs that had gathered since the earlier days, when Karl had been more active in the barn.

We drove back across his fields, sticking to the ridges. "Should have a pretty good crop of hay next year," he said. "Andy painted that hill there. Sat his easel up right about here. It was cold as the devil, but he didn't care."

I was learning another remarkable thing about the Kuerner farm. The whole farmstead was strictly utilitarian. Nothing was wasted, no move made that would not pay or save cash. A back shed was completely full of cordwood. "Sure we use our own wood to heat with." The pond in front of the house, deep and crystal clear, was full of fish. "We always have our own fresh fish, if we want it.

"A spring across the road halfway up the hill feeds the pond," he explained. "That's our water supply, too. You see, the spring is higher than the house. We have gravity-fed water to the second story of the house, and then to the barn. Springwater flows through the whole farmstead and keeps the pond full too. No sweat, no cost. Two hundred years it has run. And you think we have progress. Hah.

"That building is the old icehouse. We used to cut ice and put it in there and it would keep all year. If you didn't mind the work, it was just about as good as a refrigerator."

I remarked that his tractor was the only new equipment I saw.

"Yes." Old Karl smiled. "But it makes us money. Do you know, over in Germany when I was young, we threshed out the grain with flails, by hand? It was cut with a grain cradle,

and tied in bundles with strips of willow. The scythe blades were kept razor sharp. Each cradler carried a stone in a leather pouch in some kind of mixture of oil and urine. This made the stone bite right into the steel, and how sharp the blades were. The harvesters were always sharpening their blades. That is the whole secret of hand work, you know. It's no job at all if you have a *really* sharp blade. But a lazy man don't like hand work because it's too hard because he's too lazy to keep his blade sharp. But I suppose if there weren't any lazy men, we'd never have gotten tractors, would we?

"Back then the harvest was a community affair. The threshers each got a share of the grain, and sometimes they let the children come along after everything was cleaned up, to pick up any stray grains they could find. The children put the grains in little sacks. Nothing was wasted. Nothing at all.

"The people would plait dolls and crosses and nice designs out of the wheat straws. I wonder if anyone knows how to do those things anymore. They would sell well in stores today. And now here I am with a big new tractor. Many centuries in one lifetime." Karl smiled.

He would talk about his farm and about Wyeth in the same breath, moving easily from one to the other as if in his mind it were all the same topic.

"Only once do I know that Andy painted something other than the way it really was. I had this big barrel of cider working, and it had foamed up like a birthday cake on top, and Andy painted it. But he didn't put the foam on it like it was. 'No one would ever believe it,' he said.

"Andy and me love cider. He always has some of it around. We got Forrie Wall [Forrest Wall in Wyeth's *Man from Maine*] sick on it once." He chuckled at that.

"Andy was up in our attic and he was taken by that room with the cobwebs and the hooks fastened to the ceiling

where we hang seeds and things to dry during the winter. He decided to paint me up there. So the day before he was to start, I went up and cleaned the place out, all those cobwebs and stuff. When Andy came he took one look and hollered: 'What happened to this room?' 'I cleaned it up for you,' I said. 'But I wanted it the way it was,' he said." Kuerner laughed. "He had to paint it clean then. Just as well. Who wants people to think we have cobwebs hanging around like that, even in an attic.

"About Andy painting things so real. One story goes that a woman, looking at a picture he painted of a blueberry pie, said: 'He has the same trouble with his pies as I do. Juice always bubbles up and runs over the side.'

"That painting of me [*Karl 1948*] some movie actress bought. What was her name now . . . I forget. Anyway, she had it for a while hanging in her house and she finally couldn't stand it any longer, she said. 'That painting is just too strong. I feel uneasy around it,' she said. Now, what do you think of that? And she finally sold it. To Mrs. Rockefeller. The Wyeths have tried and tried to buy it back, but the Rockefellers won't sell. How about that? Too strong."

I told him I had a similar feeling about the painting but that I did not find him so stern in reality. Again he smiled. "Maybe I mellowed some. The Wyeths say that Andy was really painting his father more than me, and Mr. Wyeth, the father, could be a stickler, you know.

"Those two old wagons down at Andy's came from the place where Howe's old headquarters was. When we cleaned up that place I asked Andy if he wanted some old wagons. He was taken with them of course, so I hauled them over and parked them there. 'Just leave them sit right where they are,' he said. Where he saw them. He painted them in front of the house and you hardly realize that it is a modern house in

the painting. Betsy didn't think much of those old wagons· cluttering up the yard and was going to move them, but Andy can get his back up on some things and he wasn't about to move them. So there they still sit. He can be real stubborn about some things. There was some old half-dead trees down there on his property and Betsy said: 'We're going to cut those things down and get them out of here.' But Andy would have none of it. Those trees belonged there, to him. They're still there.

"What Andy likes best is to be unrecognized. When he had his show in Philadelphia, Andy and me were there looking at the pictures when two women in front of us started talking about *Brown Swiss*. 'Do you suppose that is a real house?' one asked the other. I told them I was sure it was, because I lived in it. They gave me the oddest look you can imagine and hurried away. Thought I must be some kind of kook, I guess. Well, did that tickle Andy. So we shouldered up to another painting and Andy said real loud, 'That one ain't worth sour apples.' A man spun around and shook his finger at him. 'That's no way to talk. Think of the time it took for that man to paint that picture.' Andy loved that.*

"Something else happened funny, too. We were going by the paintings and Andy leaned over to touch one to straighten it out. It was hung a little crooked, he thought. Anyway, one of the museum people saw him and came prancing over. 'Please obey the signs, sir. DON'T TOUCH THE PAINTINGS.' And Andy says: 'Oh, pardon me.' His eyes were just dancing."

One other day when I was visiting Karl we were down by his pond looking for fish in the clear water. Out of the woods

* This anecdote, and the one that follows, were told to me by other people as their personal experience too. Wyeth says they never happened, and one must conclude that both stories are folklore rather than factual history—a sure sign that Wyeth has already become something of a culture hero.

behind the house came Wyeth, sketchbook under his arm. He wandered through the orchard, turning, backing off, looking, in a hurry. Always in a hurry.

"There he is again," said Karl. "Always looking, over the same places, always finding something else."

As we stood by the springhouse talking, Wyeth came around the corner of the house. Then he saw us. He wheeled around and headed back up through the orchard to the shelter of woods, with that peculiar loping gait of his. He looked like a March rabbit, a little hungry from the winter, a little tired, but scurrying nevertheless for cover. I watched him hurrying up the hill, and I remembered the boy running down the hill in *Winter 1946*. A striking contrast, a striking similarity. The boy searching for the right way; the man, having found the way, still searching. Still running. Up and down hills. Uphill eluding the fame that he had found when he ran down the hill.

"Andy hates to be caught working," Karl chuckled. "Look at him go on those bad feet of his. I don't know what it is. He's embarrassed that people have to see him sketching things. He'd like to be invisible."

I have returned often to Karl Kuerner's farm, and one day he took me down to his springhouse in February, around the south side of it, to show me a "surprise." There in the brown winter grass grew a patch of snowdrops, catching the first warm sun, blooming white in the barely thawed ground.

"Every year they come up and bloom so early, so pretty . . ." His voice trailed off, but he was not embarrassed as so many men would be, delighting in flower beauty. He knelt and picked a flower, smelled it, looked at me, wanting me to share his little pleasure. The flower in that calloused hand, which butchered steers and shot deer and closed tightfisted on cash.

But even that was not all in the depth of Karl Kuerner. I knew his life had felt deep sorrow, too. His wife had not been well for some years, and her mind was not always as strong as it once was. And there is a story seldom told. When Wyeth was painting Karl, the picture too strong for the movie star, Karl's wife got the butcher knife from the kitchen and tried to destroy the picture. You can draw many wrong conclusions from the story. Hearing it, you must see Karl Kuerner kneeling in his snowdrops.

THE PLACE WHERE WYETH LIVES

No man understands the curse of fame until it is upon him. On his way to "success," he must court the public if it is the public that can give him his fame. But the public exacts its tribute with a vengeance. And today the informed public, in sheer numbers, makes fame vastly more burdensome than it could have been even twenty years ago.

Wyeth found this out at his Chicago exhibit. Recognized in a gallery, and pursued into an elevator, he was set upon by a group of people with mob-like fervor. An eyewitness told me: "They were after his autograph, after momentos, after photos, after statements. They were snatching at the buttons on his coat. Wyeth was lucky to get away with his clothes still on his back."

This kind of experience is almost traumatic for Wyeth. He can't understand it exactly. To him, there is no more sense in pursuing a man because of his paintings than in chasing after a plumber because he can fit pipe together skillfully.

Yet he can hardly complain about his dilemma. To sell paintings, he had to sell the public. And in the beginning, he did so without hesitancy. It was his wife who understood that

Wyeth was good enough to skirt the pitfalls of commercial art and concentrate on painting as he wanted. Wyeth is not a hermit or visionary. He can be a practical man when necessary, a fact that disconcerts and alienates that portion of the art world that fervently believes that art is only for those few who exist in an otherworldly mystique.

Wyeth is, in fact, besides being practical, a sociable sort of person. He likes to talk to people. He objects to publicity and retreats from visitors for a very unexciting reason. He wants to paint pictures, and he will not get anything finished if he talks to people all day long. Few people can do creative work, or what is called creative work, while immersed in public relations activity.

To stalk a man like Andrew Wyeth, all too aware of the problems of fame, I felt that I must break up the reporter image of me that he had formed in his mind, and throw it back at him in pieces that would fall together in the form of a very specific person. Or become part of the landscape, or transform myself into a chair in his studio. To capture him the way he captures his subjects—observing unobtrusively from a corner, nailing down his spirit as it emanates from the subjects he paints. Wyeth eludes orthodox reporting.

So I didn't hurry down to his gristmill with a camera slung over my neck or a pencil and pad in my hand, or a tape recorder bulging from my pocket. In fact, I waited until I knew he would not be there. I waited until he left for Maine. And I hoped he would know that I had waited.

The Wyeths were well acquainted with the old mill on the Brandywine just up from Chadds Ford when they bought it in 1958. Andrew had already done some painting there among the crumbling ruins. Dates of 1762 and 1706 scratched on the walls put the original mill's beginnings somewhere around 1700, possibly earlier. Around this mill, muskets

roared and cannon boomed during the battle of the Brandy-wine. The mill continued in operation for over two centuries, to a final creaking end in 1948. After that, the slow deterioration of two centuries became more rapid. What the Wyeths bought were three buildings, little more than shells: the mill itself, the granary, and the miller's house.

Approaching the home today after some eleven years of restoration, I saw the same three buildings, looking, I suppose, much as they had a century ago, with the addition of a long, open garage jutting out from the miller's house. The granary was living and working quarters for James and Nicholas (the Wyeth sons) before they moved away. Now it is principally an office for Betsy. The Wyeths live in the miller's house. The gristmill, not yet completely restored, will house a studio on the third floor and possibly a gallery on the second.

When I first arrived, the complex of buildings seemed institutional and impersonal—like a restoration in a state park. But it grew on me. I noticed first the clash of old and new: snowmobiles and sports cars beside wagons a century old. There were no gardens, no ornamental plantings. Only large native trees softened the stark beauty of stone walls and cedar shakes. Behind the buildings, on the bank of the Brandywine, the water flowed past with cool, soft stillness. I saw a few geese swimming, an abandoned duck egg in the grass, a cannon on the other bank waiting pathetically for the British, who would not come again.

Inside the mill work Lou Pepe and George Heebner, the two craftsmen the Wyeths engaged in 1958 to do the restoration.

Like most of the people who surround the Wyeths, Pepe and Heebner are unique individuals. Pepe's background was in construction work, from which he gravitated into the

highly specialized work of custom restoration so much in demand in the history-conscious Brandywine Valley. Heebner was a research chemist who quit his job to go into partnership with Pepe.

They made a contrasting team. Pepe is quiet, dark, steady-as-you-go; Heebner, fair, philosophical, a lover of sparkling conversation. Both are good with their hands and understand the materials they work with. They believe in the same values: craftsmanship, Yankee ingenuity, quality; a regard for the lessons of history; creativity through common sense and logic. They are as fine an example of the true artisan as you could find, rare birds in our assembly-line civilization today. I do not think it is by accident that they are working for the Wyeths.

I marveled at the wooden latch on the mill's front door. It closed smoothly and firmly into place without a hint of play in it, though it was obviously all made by hand from an old pattern. Even the latch spring was made of wood.

The craftsmen showed me the mill wheel. The axle was thirty-four inches in diameter and made out of green white oak. In the water it will never rot; in fact, the more it's used, the better. The tree from which the axle was hand-hewn came from the Radley Country Club and was 263 years old. The whole wheel—the undershot type—weighed eleven tons without a nail, bolt, or screw in it. It was fitted together entirely with wood pegs. Each of the cogs on the side was an individual piece of hard rock maple. The cogs engaged the wooden gears of a second axle, from which a belt ran to a generator on the second floor. The plan is to heat the building with the electricity from the generator.

The top floor of the mill, where Andy plans to have a studio, was all white plaster and exposed beams. It was a very

spare, stark-looking room, with a big expanse of window for the north light.

The restoration was mainly Betsy Wyeth's creation. She planned it all, aided by an uncommonly sharp eye for antiques and an ability for using the unusual to good effect. For instance, the weather vane on top of the mill, some eight feet tall, was the quill pattern, which you don't see very often. Betsy spotted it in an antique shop, in an out-of-the-way Pennsylvania village.

A huge carved wooden seal of Pennsylvania hung on the side of the main house. Betsy found that too in an antique shop, near Lititz.

I examined the special doors on the granary. If the Brandywine should flood, as it sometimes does, the doors can be closed to seal the building watertight.

Inside the mill, again, I noticed the painstaking thoroughness of the restoration. All the window panes were old glass, the hinges either old, or exact reproductions. On the second floor the stone wall was left exposed, without insulation, because the original mill didn't have insulation.

The workmen offered to show me how the mill ran. They raised the water gate that let the water rush in from the millrace against the paddles of the huge wheel. With surprising ease, it began to turn, gaining speed with only a quiet slap-slap of water against wood. Eleven tons of wheel whirled around with effortless smoothness. It seemed to me at that instant that the lifting of tons of steel into the air by four jet engines was no more marvelous than a mill wheel—and not half so romantic.

I left the Wyeth place with an uncanny feeling of disappointment mixed with wonder. I had gone there knowing that the mill buildings had served as subjects or background

for scores of Wyeth paintings. While the workmen restored, Wyeth painted and preserved. But paintings like *The Mill, Mill Buildings, The Granary,* and so many others of the same subjects did not depict the mill or the granary I found. The houses in the background of pictures like *The Outpost* and *The Country 1965* are not where the Wyeths eat and sleep. *Marsh Hawk* has little to do with their home (and even less to do with marsh hawks). The environment of the paintings is another world, where light and shadow and a little color are important. It is a world beyond stone walls, hawks, or Brown Swiss—a world where you look for your own light and shadow. And *that* you will not find where Andy lives.

There you will find a cannon facing upstream and, perhaps, a duck egg abandoned in the grass.

THE COOLING SHED

Not far from the Wyeth home wanders one of those narrow country roads famous in Pennsylvania for going no place in particular. If you drive down it, praying that you meet no oncoming vehicle to force you into the ditch, you pass the Wylie farm, a fine old homestead where N. C. Wyeth used to buy wood for winter fuel. Andy Wyeth, the child, often went along with his father then, and he has continued to visit the farm ever since. It was here that he painted *Cooling Shed*, which, probably because of my own background on a dairy farm, is one of my favorites.

Bob Wylie set the oil can down beside his chain saw and took me to see the cooling shed. "Andy had been in and out of here no telling how many times, and then one day, he up and decided to paint it. He threw a little scrap of carpet down there on the floor of the walkway, sat down, and went to work. It was awful cold that day, too, but he didn't seem to mind."

Wylie's milk house surprised me. Like other scenes of Wyeth paintings, I found the reality to be physically smaller than the painting of it suggested, but unlike the others, the real cooling shed had about it the same mood and feeling of

the painting. Cool white. Subdued. Quiet as a nunnery. Spare, uncluttered. Andy did not have to delete the unnecessary. The Wylies had already done that, not only from their milk house, but from their lives. And Bob Wylie, standing there, showed me his milk house with a quiet pride that was very much like the spirit of the cooling shed.

But the buckets in the painting were not in place, and Bob knew that I knew they were not in place.

"Mother is washing today so she is using the buckets. Otherwise, they'd be right there, just like in the painting. Just where they're supposed to be.

"The water for the cooling shed, for the whole place," he continued, "comes from a spring back in the woods a quarter of a mile away. It's been coming I guess since before the Revolution. Feeds by gravity all over the house and barn. The lead pipe that carries the water from the woods is over a hundred years old.

"I wanted to switch over to a Grade A dairy once. The Agriculture Department and the health people said that my water wasn't pure enough to use in a Grade A dairy. Too much bacteria or something in it. They said *that* about water that people have been drinking for a couple of centuries. Guess that's what makes it taste so good." There was just a whisper of a smile on Wylie's face. His way: a quiet look at the world; a faint mockery.

"I've sold most of my cows now. It's hard to keep a dairy going without good help and you can't get that anymore."

I asked him how well he knew Wyeth. "Andy and me started school together," he answered. "That lasted about three months. Then his father took him out of school for private school. Yeah, we started out together. Now look where he is and where I am." Wylie smiled. "Not that I would trade places with him for anything. I remember even in first grade, Andy

seemed to be older than the rest of us. Maybe it's because he was a genius."

We walked along, while Bob showed me his farm.

"Up on that hill is an old cistern. Quite a hole in the ground. Sits higher than the second story of the house. They used to pump water into it with a windmill, then from the cistern the water would feed by gravity anyplace in the house. Pretty slick, those old-timers were.

"My father bought this farm in 1900. See that tree. I never would have thought a silver maple would grow that big. Well, anyway, he bought the place in 1900. Before that it was owned by a nurseryman called Biddle. Biddle had a string attached to the shutter of his office out by the entrance that connected to a bell in his bedroom. If anyone tried to break in at night, he'd know it."

I told him I liked his old barns, especially the corn crib.

"Yeah, old buildings look nice to people who don't have to work in them. Phil Jameson used to bring his art class out here to sketch our barns. No telling when that corn crib will just fall down. Jameson says that gives it character. After we whitewashed the big barn, he wouldn't sketch it anymore. Said we ruined it. That's the human race for you.

"Andy is sort of like his father, only more outgoing. His father could be reserved with people. Andy and me have been neighbors and we grew up together, but I see him only a couple of times a year anymore. He is a good neighbor and we respect him. But we know that and figure Andy knows it too, so we have no need to run down there all the time to prove it. I've never even taken a look at his restored mill, though I hear it's something."

I asked him if people ever came to see the cooling shed. "Oh yes. Many come. We have relatives from Philadelphia who get excited about every twist of Andy's finger. They collect all

the information they can about him, save every print and picture they can get." He looked at me a little sheepishly, suddenly realizing his criticism embraced me too. "I guess it don't hurt none. Now, right across the road over there is a retired admiral living. They say he was second in command under Halsey and was at the signing of the surrender in Tokyo. But who goes to see *him*? They come and look at our old milk house."

Bob Wylie picks up his chain saw, gets ready to attend to more important matters. There is wood to cut and cows to feed, and barns to whitewash and manure to haul. While Bob Wylie lives his fine, wine days and drinks his water that the USDA decreed unfit for washing Grade A milking utensils.

ADAM

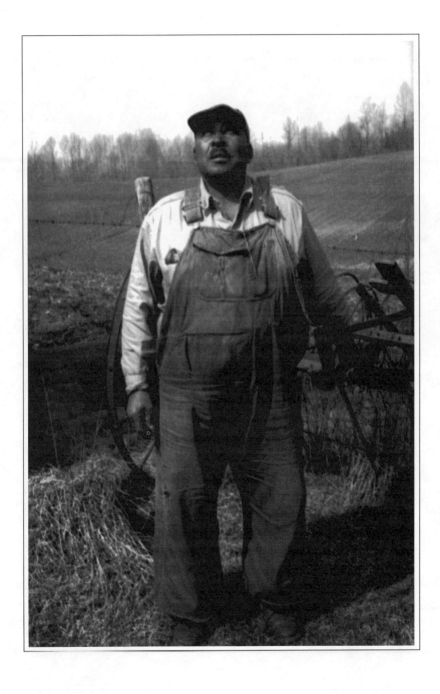

Up from Karl Kuerner's farm, in a corner where two roads meet, stand the walls of a crumbling octagonal building and, nearby, a few gravestones, some broken, some fallen. Once a Quaker meetinghouse, the building that stood there became a Negro church later— Mother Archie's Church, named after the woman who served as minister for many years. Huddled against it at one time, rather haphazardly, was a house. Wyeth has painted this corner, this church, this hill, many times.

If you know the story of Mother Archie's Church, you can look at the paintings and imagine that Andy was thinking about the little tragedy that was played out here at Archie's Corner. But, on the other hand, if you know the story and don't think it was a tragedy, you can't accuse a painter of misrepresentation of the facts simply from the way he dabbled paint on a canvas. This is the advantage of painting. Words are more explicit. They are not, really, but men think they are. So the writer must be very careful. He cannot say that he puts sentences on paper only because the letters look pretty. Or the light strikes them in a way that makes a beautiful design. He must put sentences down that tell the truth, or

if, like Pilate, he doesn't know what truth is, he can put quote marks around the sentences, or use a qualifying adverb or the subjunctive mood and then run like hell.

The truth is that Mother Archie's Church is gone now, and the black congregation is gone too. If one man tells you that "the people were forced out of the area to make the land more desirable for sale to whites," another will say: "That isn't true. The church died a natural death."

One way or the other, it is safe to say that the blacks are all gone now. All except one. All except Adam Johnson.

Adam is a handyman-farmer who lives next to the crumbling walls that used to be his church. He still goes there, too, keeping the graveyard trim, watching out for the headstones.

I stop to visit Adam Johnson with my heart pounding as I pound his door, knowing that I am going to meet another famous Wyeth painting, another Wyeth friend, another place Wyeth has "grown up on."

I tell Adam when he comes to the door that I want to talk to him about Wyeth. He invites me into his little home and the telephone is ringing and I wonder if he knows it, since he is so deaf. He has been upstairs spraying some insecticide around the windows where the bugs might want to come in when the weather warms up a little more. Adam's house is spotless, even though his wife Etta is dead now. Adam takes care of his own.

"You one of those fellers that takes pictures?" he asks, a little suspiciously. I shake my head, lie a little, tell him "not today, anyway." The phone is still ringing.

"Your phone is ringing, Adam," I tell him.

He cocks his head, not comprehending.

"YOUR PHONE IS RINGING."

He smiles a big watermelony smile, the best smile I have ever seen anywhere on any face. He shrugs lackadaisically. "If people really want to talk to me hey they'll come by," he

shouts. "Besides, I don't want to do no jobs for them in this kind of weather hey I'm seventy now hey I'm seventy." Perhaps because he is so hard of hearing, Adam even sounds his punctuation marks. "Hey" means simply "period" or "comma," or if he is talking about Faith, it means "exclamation point."

Adam Johnson's skin is like Iowa loam, rich black-brown and ageless. There is an amber hue around his eyes, and you can tell by the way he peers so closely at what he is trying to see, that his sight, like his hearing, is seventy years old, even if the rest of him has aged more slowly. His girth is mammoth; the bib overalls seem stretched over a fifty-five-gallon barrel.

And such hands. Wrinkled, calloused, creased—the skin, where it is tight between the knuckles, is like black mica; the rolls between the creases, leather tough and smooth. Impetuously, I touch his hand. I want to know it well.

"Why hasn't Andy painted your hands?" I roar down close to his ear. He looks out the window, eyes closing, tongue wetting the corner of his mouth. I start to roar again, but he stops me, nodding to indicate he heard well enough. It is not any kind of a question he is expecting. He has to think about that a little. Think about me.

"Well, he did once," he finally says. "Come here."

I follow him into another room, where a huge painting all but covers one wall. "That's me, holding the axe," said Adam. "Andy did that when he was fifteen years old hey I was a woodcutter in those days. See, that is the house behind me, and there's my mowing machine, and chicken coop and haystacks; he even put in the outhouse hey See that chicken coop. I raised a thousand chickens in there twice a year back then hey"

It is true, Andy painted Adam's hands gripping the axe, but what I notice most of all is the axe blade, ablaze with light.

The chicken coop, Adam's hands, the machinery, the house are kind of an afterthought. What caught fifteen-year-old Wyeth's eye was the light playing off that axe.

I get my book of Wyeth paintings and open it to the one of Adam. I lay it out on the table. It is easier than trying to talk. Adam squints at the picture.

"Yeah. That's me. He paints my face hey He spends all the time on my face. But he wants me to look down hey See. He makes me look down. People that know me don't like it much that they can't see my eyes hey Say it don't look like me."

"Do you like the painting?" I ask.

He straightens up, looks out the window, "I don't care much for pictures. I don't care much for the whole business hey Andy wants me to stand there and look down while he draws. And I stand and I stand and I stand, and when I gets tired I tell Andy, 'That's all for today' hey So he quits and we go at it again next day. It was so cold hey and Andy, he was kind of sick then anyway. 'Andy,' I ask him, 'Andy, why do you do this? hey You don't *need* to do this. Look at me hey I'm *poor* and I wouldn't do it.' But he just grins at me hey He just grins." Adam sighs, shakes his head, smiles, and closes his eyes. Then he opens them again. "See that coat I'm wearing in the picture. Andy wanted it hey He wanted it. So I gave it to him, and he wore it awhile hey"

"Why did he do that? Was he cold?" I asked.

"I don't know. No, it wasn't the cold. Guess he needed it to finish the painting. I don't know. He likes to wear old coats, though."

I point to another painting in the dining room.

"Miss Carolyn* did that one. She gave that to Etta. Etta used to help with the housecleaning hey When Etta gone, the

* Andrew Wyeth's sister.

family talked about selling the paintings and Andy he got wind of it hey He came over here one night and says 'I heard you were going to sell the paintings' hey I tell him, Andy, you get out of here. Ain't nobody takin' nothin' out o' here unless they take me out first hey

"Andy and me have friendship. All my neighbors are good. They help me, I help them hey But Andy, he have more Faith than me hey I help people, but he keeps Willard right in his place hey I help people, but not in my house. Andy has more Faith hey If everyone like Andy, be no trouble in this world hey"

"But Andy doesn't go to church very much," I say to him. "Someone told me he was a retired Christian."

"No matter. Andy got Faith."

I turn the pages of the book of paintings and point to Mother Archie's Church. Adam squints, rises up, looks out the window. He squirms in his chair, licks his lips. He is not comfortable thinking about Mother Archie's Church.

"All the world will be tamed except man," he finally says.

I look bewildered.

"I saved it from being torn all the way down," he continues with pride. *"I still have the walls* hey There was a house there and a fence went all the way around. And they goin to tear the house down. And we said they could tear the house down, but not the church hey There is no deed to the church and graveyard. That church belongs to us *forever* hey And some say, tear it down, and some of *them* folks died not so long after that too. You can't know the ways of the Lord but evil can't beat Him. The wicked can't have victory even when they think they got it. The trouble is that man is not tamed hey" Adam is shouting now. "Man is the onliest thing that kills his own kind. The birds and the fishes and the animals they all learn how to get along with theirselves. But man cannot be tamed hey"

"How did the fight over the church come about?"

"Why, they tore it down, that's how it come about hey They tore it down. They have a big lawyer and we gets lawyers and all the lawyers, they say they take care of it right hey They take care all right. Some of the boys, they was talking up a fight and I comes in and I tell them, that's no good. Vengeance belong to the Lord hey Evil cannot beat good." Adam stops. He starts several sentences, but lapses to silence. Finally he closes his eyes and smiles. The truth in him is too big to talk about.

"You got Faith?" he asks abruptly.

I nod, not sure what I am nodding to.

Adam lifts his tremendous bulk from the chair, climbs the stairs, and clumps across the room overhead. Each footfall shakes the little house. Back down he comes, thump, thump, thump, and places a big Bible on the table. It is tied shut with string, which he loosens slowly, in silence. Then he takes his billfold from the vest pocket of his overalls, searches through it, brings out scraps of paper upon which are written chapter and verse numbers. And he begins to page through his Bible, licking his finger first, and then very tenderly turning from one quote to another, reading, savoring each word. And when he finds a passage even more suitable for the occasion than he had imagined it would be, he not only reads it aloud, but makes me read it too. "See, look here." And he reads: "In what place soever you shall hear the sound of the trumpet, run all thither unto us; *our God will fight for us.* Hey We don't need to fight.

"Now you take that man, Luther King. They shot him down now didn't they hey It look again like evil has the upper hand. Well, it don't hey You cannot destroy the good. You, you . . ." Adam gropes for words tremendous enough to bear the weight of the absolute truth he wants to utter. There

are no words fitting enough. "And they shoot Kennedy too, and they think that a great victory because that man, he would have been the *leader*. So evil is all happy, but not for long. You'll see. You can't beat the Lord hey"

All the time, Adam keeps paging and consulting his notes. He wants to show me where the Bible says that all the creatures of the earth were tamed except man, but he can't find it. It doesn't matter. He finds many other choice morsels to quote. I catch the spirit of it. We shout back and forth, on a high theological plane. We trade verse for verse, canticle for canticle, proverb for proverb. We hit the pinnacle of the inappropriate, climb summits grandly beside the point, scale heights of the non sequitur. I get hoarse; Adam runs to silence. I try to steer him back to the world of everyday living; the world that tears down churches. But he thinks I know the whole story. He chooses not to go into detail. And it is too difficult, shouting, to drag it all out of him.

"But I saved the walls," he repeats with satisfaction. "Andy, he tried to buy the place. Twice he tried to buy it hey so the people who lived there, the Smiths, could stay on. Andy painted them, painted Evelyn. But he couldn't buy the place. So you know what he done hey He painted it. You cannot tear down what he paints. And everybody knows hey Justice hey It will beat them every time." He stops then, closes his Bible, closes his eyes, smiles. The subject is ended. I wait. But the subject is ended.

I point to a small crude painting on the far wall.

"A boy down the road, one of our people, painted that. Andy thought he had promise hey Thought he could break the boy in. Took him down there with Jamie and Nick to teach him, but the boy never took to it. Nor Nick either. Only Jamie took to it."

Standing up to examine a photograph of N. C. Wyeth on a shelf, I nearly hit my head on an old-fashioned, low chandelier. Some of the cut glass baubles that once hung around the bottom edge of it are missing and the globes for the light bulbs are gone. I can tell that Adam likes it.

"Etta brought that fancy thing home one time from a secondhand store or somethin'. And I said to her, don't you bring that light in here. That's frivolous. But it was pretty and she was bound to put it up. I took the globes off so they wouldn't get broke. They're over there on the shelf. See. Pretty things aren't they?"

I suggest that Adam show me his tiny farm. He heaves himself out of the chair. "Show you my mower, anyway," he says.

Going out the door, I pause in his clean little kitchen.

"That's a good stove hey" Adam said. "Only one like it I ever had. All the burners don't turn on anymore, but I'll keep that stove as long as there's one left working."

"Do you garden any?" I ask.

"Not now. Too old for that. I did my share, now, I did. We raised everything on this little bit of land. *We made do hey* But now I just haul garbage and mow lawns and such odd jobs that I can get."

Outside, Adam leans on an old hay rake next to a shed and I know I have to take his picture there. So I ask him. He nods, as if he knows I am going to ask. I flick the camera at him a couple of times to get him used to it, then begin to try to position him around. It is very strange. He strikes a pose, any I suggest, and holds it. He is a model. A pro. I have noticed the same thing with Karl Kuerner. They seem to understand about pictures. Andy has trained them well.

We walk over his tiny farm. His sheds are all made of scrap wood, yet neatly put together. Everything is neat and orderly.

Adam Johnson wastes nothing of his own, and puts to good use what other people have thrown away. He has raised and educated his family, owns a good house. His pickup truck looks nearly new, and his driveway is blacktopped.

Adam is rich: Adam is poor; Adam is old; Adam is young; Adam is wise; Adam is simple.

Adam is Adam.

Hey!

8
CHRISTINA'S WORLD

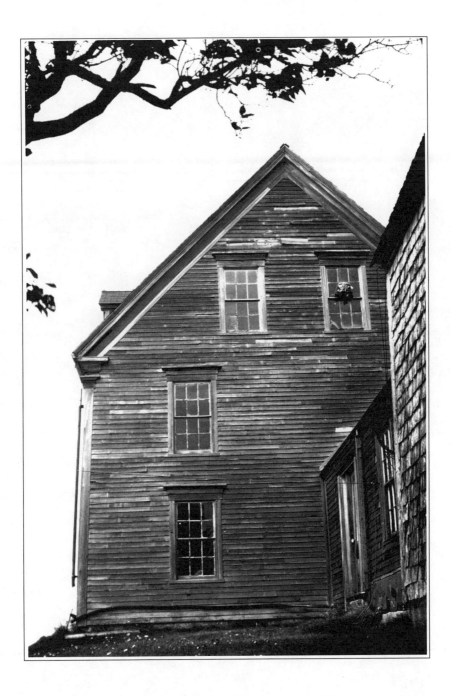

My first journey to Maine, after only one meeting with Wyeth, was successful only by the sheerest accident. I prepared for the trip with unusual cunning: I did nothing.

All I knew about the area around the mouth of the St. George River—Port Clyde, Thomaston, and Cushing—was that Wyeth spends half his life there, June to November. I noted that on the map Cushing was represented by a tiny blue circle, and Thomaston by a solid blue dot. I couldn't tell a lobster trap from a blueberry rake.

In fact, I fancied the whole trip as a sort of spy adventure, in which I, perhaps disguised in a sou'-wester, whatever that was, would slink through the pine forest, roam the rock-strewn beaches, or ride around in a dory while unobtrusively observing Andrew Wyeth and the people he painted. They would perform for me without knowing it, speak their salty aphorisms, sparkle with local color. Simple.

Ten minutes after I arrived at Thomaston, my whole ignorant, romantic plan collapsed. I could barely understand what people were saying, much less try to sound like one of them. They don't talk English up there in Maine, or rather

they *do* talk very much like the English, and it was not something I could master on the spur of the moment. So, fortunately, I didn't try to pretend anything.

I checked in to the General Knox Hotel and found there was still an hour of daylight to work with. Logic told me the first thing to do was to go to Cushing and find where the Wyeths lived, and use that as a sort of starting point from which to, well, stumble about. The road to Cushing? (The *g* is silent, by the way.) Simple, said a local man in the hotel lobby. There was only one road out of town that went there. He told me how to find it.

I drove out of Thomaston. Passed neat little homes and farmsteads where the barns are connected to the houses. Came to a store. The sign said Fales' Country Store, Cushing, Me. I was getting close. The town must be just ahead.

I kept driving. Finally the road branched. There were signs beckoning on to Friendship, Point Pleasant, Hathorne Point. Nothing about Cushing. Obviously, Cushing was so close that a sign would appear superfluous. I drove on. Another sign: "Friendship: Town Line." Woods on both sides of the road. A bird singing. Wind in the treetops. "Friendship: Town Line."

I turned around and started back. The sun was going down, and I was hungry. Back where an arrow pointed toward Hathorne Point was a sign for a restaurant: Our Place. I proceeded in that direction.

Eventually the road turned into a graveled path that led into a barnyard. Gray barn on the right, roof caved in, huge old weathered house on the left. There could hardly be a restaurant on down that lane, but I was determined now to follow it right to the ocean, where it seemed to be heading. Passing the old house, I happened to look back.

I hit the brakes. I was staring at Christina's World. There couldn't be another house quite like that one on earth, and in

the lowering sky it cast haunting loneliness. There were old trees and a clutter of ancient farm tools that Wyeth had not painted in the picture. I must have been not too far from where Andy painted Christina in the grass.

Unfortunately for such a moment of mood, there were mundane matters to settle. Like where did the lane go? Like was I going to find something to eat? I drove on slowly, rounded a clump of trees, and there was Our Place, right on the ocean. A restaurant like none other I have ever seen.

It sat on a pier above the water, a plain cement-block building with a spread of fishnet draped from the roof line. Without the sign, Our Place would have looked a good deal more like a chicken coop than a restaurant.

I went inside. Four women were playing Monopoly on one of the dining tables. For ceiling there were bare two-by-fours holding up the roof. The walls were the honest cement blocks, hung with pictures. Looking out the ocean side, I saw boats anchored offshore, rocking at their moorings. I sat down. One of the Monopoly players got up, a bit annoyed at having her game interrupted.

While I ate, I struck up a conversation, commenting loudly that I had never tasted seafood any better.

"Yeah. It's a lotta hard work," said the woman behind the counter. It turned out she was Mrs. John Olson. Her husband was a lobsterman who owned the place and who bought lobsters from the other fisherman here at his pier.

I told her, as if I had to, that I was new to these parts and that I had a problem.

"What's that?"

"Just where in heck is Cushing?"

Her reserve changed to open laughter.

"Well, if you came from Thomaston, you passed right through it. That whole, well, all along the road there, both

sides of Fales' store—you saw that, didn't you—that's all Cushing. *It's all Cushing until you get someplace else.*"

While I was telling my experience, a man came in and sat down at the counter. "We got a story that you'd appreciate," he said. "There was this old-timer in Cushing, standing out in the yard, and a tourist went tearing past, driving fast. A little later, the old man noted that he was seeing that very same car coming back from the other direction, only not quite so fast this time. And then, a few minutes following, son of a gun the same guy is back again, only now he is going very slow. Out the window of his car, he yells, 'Say, can you tell me where Cushing is?' The old man slapped his knee, laughed, then threw up his hand. 'Stop right there, young feller. Don't you move one damn inch farther. You're there!'"

I got up, went to the counter, peered closely at the print of *Christina's World* on the wall behind. They were all watching me. "I've always liked that one," I said. "It's kind of eerie to see the real place after you've known the painting."

"An awful lot of people come to see that house," said Mrs. Olson. "Funny. That place has been there two hundred years and then a guy paints it and all the world comes to gape. But what *Andy* was painting ain't there anymore."

"How's that?"

"Well, Christina is dead, and Alvaro, her brother, too. Well . . . you just had to know Christina to know what I mean."

"What was she like?"

"Oh Heavens, you had to know her."

"You did?"

"My husband is her nephew."

"From the paintings, I'd say she was beautiful on the inside, but ugly on the outside. Or is that just corny?"

"No, not corny. She had a beautiful spirit, I guess you'd say.

And smart. Andy Wyeth once said she had more class than all the Queens of England. But she was crippled up, you see, and yet she took care of herself."

"Do the Wyeths come here to eat?"

"Often. That's Nick's boat out there."

"They must live close by," I suggested casually.

"Well, yes."

I could sense a holding back. Someone at the Monopoly game piped up. "He lives in Cushing!"

Everybody laughed.

Outside, I found John Olson in the shack on the pier, getting ready for the early morning run of the lobster traps. He had the narrow, sad face of the Maine coast, or the kind of face I associated with the Maine coast, and the patient eyes of a fisherman.

I asked him questions about the lobster business and he answered patiently. A bucket of fish heads caught my attention.

"Stinks awful, doesn't it," he commented.

I nodded.

"You get used to it, so you hardly notice."

"Just about the way a farmer gets used to manure," I suggested.

"Yes, that's right." He looked at me sharply. "You a farmer?"

"Sort of. Your business here is a lot like farming, I think. Boats instead of tractors; lobsters, clams, and fish, your livestock; weather your chief worry—and even your womenfolks complain about having to help out like farm wives do."

He smiled his sad smile. "That's just right now. It *is* about the same."

"You're related to Christina."

"Yes, she was my aunt."

"You must know Andy Wyeth."

"Yes. Do you?"

"I've met him. I'm no judge of paintings, but I think he's just okay."

"Ayuh. Me too," said John.

"I guess he must live around here close."

"No, well, yesss. Sort of. Everybody always asks, you know, and Andy, well, we try to keep—"

"Yes, I understand. He can't have people pestering him all the time."

He looked much relieved. Now he didn't have to say it.

Next morning, a cold steady drizzle drummed at my window. Down in the hotel lobby, I asked the clerk if she knew Andrew Wyeth.

"Who?"

"Wyeth, the painter."

"Oh him. Ayuh, I know him. Not personally. He's summer people, you know." She thought a little bit. "But he fits in pretty well."

"Where's he live?"

"Out in Cushing somewhere." She dismissed the question with a wave.

While I was eating breakfast, the man who had given me directions in the lobby came in for coffee. I shared with him the remark about Wyeth fitting in even though he was "summer people." "Reminds me of a story," he said. "A man moved into a community north of here when he was four years old. He died at age ninety-three and his obituary in the paper read: 'We loved him as if he were one of our own.'"

When I asked somebody else where Wyeth lived, I got another vague answer.

If the people of Maine wouldn't tell me, I'd find out all by myself. I knew Wyeth's house was along the ocean on

something called Broad Cove Farm, back of one of the myriad lanes that branched off the Cushing road. I'd find it.

Back and forth through "Cushing" I drove, rain hampering my view. Out in a field I saw a huge rock—unmistakably *the* rock in *Far from Needham*. Aha, I told myself. This must be Broad Cove Farm. See, there's Broad Cove Church, just nearby. Back along the ocean beyond that rock, Wyeth must live. Brilliant. Only I was dead wrong.

I parked the car equidistant between two no-trespassing signs and plunged into the woods. Like an Indian I moved. Like a very wet Indian. In some places, where the thickets made walking impossible, I crawled. Where the underbrush was even too thick for that, I detoured, avoiding open spaces like a miserable poacher.

Finally, I reached the shore. All I had to do now was keep walking until I came to the house. What I would do if I did run into Wyeth, I had not the faintest notion. The inanity of the whole idea appealed to me. He probably wouldn't even remember me from our meeting at Hank's in Chadds Ford. I would just be some lonely beachcomber appearing out of the dismal rain and he would invite me in for a cup of coffee.

I walked. There were quite a few houses along the shore and not one of them had a studio nearby. The houses were all closed for the winter.

I walked. The wind picked up and so did the rain. Idly I remembered reading that Maine had 3,000 miles of coastline. After a while, there were no more houses. Just trees. Insane.

I wearily left the coastline and headed inland for the road and my car. I noticed a red maple aglow in the brown woods. Beautiful in the rain. I walked on. Found cranberries on a hillside. They had to be cranberries; they tasted that way, anyhow. Onward . . .

Up ahead I noticed a red maple. A very familiar red maple.

I had walked in a circle right back to that same tree. I stopped on the lee side of it and tried to scrunch down out of the rain. Only my wife knew where I was: somewhere in Maine.

I struggled to my feet. Moss always grows on the north side of the tree. Except in Maine. It grows all the way around in Maine. And you can't get directions from the sun when it doesn't exist. Finally I ran into a rusty strand of fence. Relief. Fences always go somewhere.

Back on the road, I still had a mile of walking to reach the car. At least a mile. Exhausted and hungry, I drove down to Our Place. Pneumonia I could risk; starvation never.

In this sorry condition I stumbled into the Olson restaurant. A card game had replaced Monopoly. Everyone paused, staring in disbelief at my sodden condition. Then someone clipped: "Well, did you finally find Cushin'?" Gales of laughter.

So I gave it to them straight. I told them I was a writer and I had come to Maine to find out what Wyeth's country was *really* like and that I darn well had found out, and for all I cared they could roll up the whole state and shove it into the ocean. They were delighted. I sat down at the card table, and they dealt me into the game. As simply as that, I was more or less accepted into Hathorne Point society. And while I told them about getting lost looking for Wyeth's house, I lost fifty cents in whatever game I was playing. But they told me where Andy lived.

That afternoon, I found Fred Olson, Christina's brother, at the old gray house. "You should have been here for the auction," he told me. "Thousands of people came and they bought everything. One woman arrived late, and she was almost in tears because there was nothing left to buy. Finally she spotted a busted old chair we'd thrown out on the junk pile and drug that up to me. 'How much?' she asked. I didn't

know what to say. It was worthless, not enough left there to repair. 'Four dollars,' I said. She gave me five and went away happy. She'd have paid twenty for it, I'm sure." He shook his head in wonder.

The Olson farm and house is an art museum. It holds no masterpieces, but is itself the matrix out of which came nearly 200 Wyeth paintings and drawings. The kitchen is, as in so many of his works, smaller than the paintings of it seem to suggest. I could still see how the lower part of the wall, as far up as crippled Christina could reach, had been cleaned more often than the top part. The old iron stove was still there, and a box for firewood. Upstairs was the mirror on a closet wall where Andy had seen himself in its dusty surface and painted his ghostly reflection. "And there's where he painted that curtain blowing in the window," said Fred. "From this second-story window he saw Christina out crawling around the field picking blueberries, and that's how he got the idea for *Christina's World.*"

We walked around outside, while I took pictures. I tried to photograph the house exactly the way Wyeth painted it in *Weather Side.* Olson laughed. "You can't get it just right in a photograph. Andy used to watch people trying to do what you're trying to do, and how he'd laugh. You just can't get it all in your picture frame the way he did."

"I see the rag is still stuffed in the broken window just the way he painted it," I said.

"Yes. We won't take that out. That belongs there now. But we had to watch like the devil during the auction. People wanted to take that rag for a souvenir. Can you understand people? I can't."

I peered into the hen house, the smokehouse, strolled slowly among the old farm tools in the high weeds.

"Did Andy ever paint you?" I asked.

"No, he never. He painted Alvaro once, but Alvaro didn't want to be painted. Andy never asked me. He's painted on my farm quite a bit though. Once I saw one of his paintings that showed a bridle on a nail by a barn window. It looked awful familiar. Sure enough, it turned out to be my bridle in my barn. Only no one would have seen it the way Andy did. There was cobwebs and junk hanging all around it that he didn't paint."

"What do you think of his paintings?"

"Well, I guess I'd prefer Andy's to someone else's, knowing him and all. But I don't understand art, I guess. I don't care a thing about paintings. Sometimes, I don't think many people really do. My wife and I—well, when Christina died and Alvaro, just a couple of months apart, well the phone just rang constantly. Reporters calling from just everywhere. Asking the silliest questions. One of them wanted to know if we had burned a bonfire over Christina's grave. He'd heard there was such a custom up here. Now, what do you suppose he meant? People are weird, I tell you. What's all this old house and stuff have to do with art anyway?

"Originally, this house had a flat top on it, a widow's walk. Then the third floor was added under a peaked roof, to rent out to boarders. We took in boarders when I was young. Betsy Wyeth, Andy's wife, her family had a place nearby, and Betsy became acquainted with Christina when she was young. So Andy got to know her too, through Betsy."

"What are you going to do with the house and farm now?"

"We're selling it. There was some talk about the state buying it up for a historical site, but they haven't yet. Some think it is a shame to sell it, but people are going to carry the whole thing away piece by piece, anyway. We have to watch all the time. Something disappears nearly every month. I'm just a carpenter and a farmer. I don't understand these people."

Betsy Wyeth

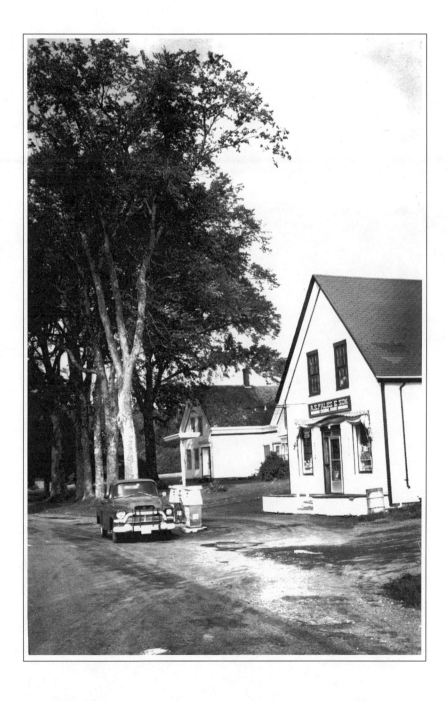

\mathbf{T}hat evening I decided to start acting like a sane, practical reporter. Which turned out, as I had instinctively felt before I went to Maine, to be a mistake. I called Andrew Wyeth. Miraculously, he answered the phone. I jogged his memory by connecting myself with Sandy Flash, then told him I was actually a writer and an editor and I was doing a story on him.

I could almost feel the line going dead on me. He said he didn't have anything more to add to what he had already been quoted a hundred times as saying, but that it was all right with him whatever I wanted to do.

Would he be available for lunch, dinner, an afternoon chat, tea for two, tennis, a tic-tac-toe tournament? Nothing worked. A series of pleasant, patient, firm nos. He was very busy finishing up a painting over on Monhegan Island and had several appointments in the evenings, etc., etc., but it was perfectly all right with him any story I wanted to write. "Just so I don't bother you," I finished for him.

I had not noticed before the interesting way he talked. It wasn't Pennsylvania and it wasn't Maine. Over the phone, he sounded like a Richard Burton who had spent too much time

in Minneapolis. He chuckled at my remark, but an embarrassed chuckle. "You need a reporter hounding you like I need a hole in the head," I admitted. His repressed laugh acknowledged agreement, "Well, thanks for talking. You could have hung up."

I went to sleep vowing my monthly vow to destroy all telephones. I hate them. Another day of stumbling along the beach—the right one—would, or might, have ended in success. After the phone call that was out of the question.

Next morning I drove to Wyeth's place. I wanted only to see it, like every curious tourist, and if he was over on Monhegan Island, there'd be no embarrassment. I followed the winding lane back through a pasture field past the main barn and house to the little place on the shore. A jeep-type truck was parked out in front. I pulled up beside it. The place seemed deserted, but having come this far, I felt committed to going on with it. Might as well go up and knock on the door.

I knocked. I felt relieved when no one answered. I turned, walked slowly across the lawn back toward my car. Behind me, I heard the door open. Betsy Wyeth stepped outside, invited me in. She appeared to be extremely nervous, but couldn't have been half as uncomfortable as I felt. We chatted a little. She apologized for not remembering our meeting at Hank's in Chadds Ford. "There are just so many people to remember," she said. But she knew I had called the night before.

We went inside. The phone started ringing. She answered it. No sooner had she put the receiver down than the ringing started again.

I looked around the room. It was done authentically in early American, tastefully accented with primitive antiques,

the kind I amateurishly collected myself. I could have sat there all day just looking.

But the third phone call sounded personal, so I went back outside. There was no privacy for the Wyeths even on this lonely corner of Maine. I remember thinking that a good reporter would have stayed there, brazenly listening. I loathed the reporter in me; I would never make it this way. Not my style.

Wyeth's studio was off to the left of the house down close to the shore. A stone wall ran along in front of the house—the stones put together the old way, without mortar. I knew it was the wall in *The Sweep*. The sun broke through the clouds for the first time since I had arrived in Maine. I wondered if Wyeth was on Monhegan Island or working in his studio. The setting was too idyllic for work. I would never write one paragraph here. I'd be too comfortable.

I went back into the house and during lulls in the ringing, Betsy and I tried to talk.

"I'm plowing through the morning's mail," she said, pointing to the pile of envelopes on the table.

"Is it that way every day?" I asked.

"Oh, not always, But just about."

I tried to tell her about my excitement in finding the subjects Andy had painted.

"But aren't you disappointed?"

"Not really. Everything is usually smaller than I thought it was from the paintings, but I enjoy seeing how he edited out all the stuff that would have weakened them."

She smiled. "Well, at least, after that, you won't say Andy paints like a camera."

I told her I was trying to talk to as many people that Wyeth had painted as possible, hoping to write a story about him

through their eyes. "Of course," I suggested, "he has painted you often."

Betsy shook her head. "I'm sorry, really I am, but I'm not going to do one of those wife-of-the-famous-man sort of things."

"Well, they say much of his success is due to you."

She laughed, looking out the window, then turning quickly, catching me off balance:

"Who says that?"

I could almost hear the sound of a steel trap snapping shut. I was just bluffing and she knew I was just bluffing and I had an overwhelming hunch that I was dealing with a mind a good deal faster than mine. I am not the best poker player in the world, but I usually know when to fold.

I grinned and admitted that the only person I knew for sure who said that was me—that I said it only to get her reaction. But she knew that. And then I told her that I didn't blame her for not handing out interviews. I wouldn't either.

I felt better then. She seemed a bit less guarded. She promised to read over my story when it was finished, and we turned to talking about the mill back in Pennsylvania. When I left, she suggested I see Adam Johnson, though it would be difficult because of his near deafness. I didn't tell her I had already talked with Adam. "You should meet Forrest Wall, too, before you leave Maine," she concluded.

I thought as I left that I should ask her where Forrest Wall lived, but she knew I could find out, and she knew that I knew that she knew I could find out. With a person like Betsy Wyeth, most of what makes up a normal conversation is superfluous chatter.

"And stop down at the grocery store," she suggested. "Mr. Fales has a painting of Andy's that I think he'll be glad to show you."

"Andy can be two different people," said Irving Fales, behind the counter of his neat little store. "When he first comes to Maine in the summer, he is relaxed, sits around and talks all day. But I can tell right away if he's in the middle of a painting. He'll pick up a loaf of bread, put it down someplace else, move cans of food around. His mind is with that painting back in his studio.

"Andy uses our store sometimes for an unannounced art show when he finishes a painting. I remember especially when he did the portrait of Eisenhower. I don't think he likes to do portraits of famous people, because, you know, he won't paint you any better than you look. He brought the painting in here and set it up among the cans of vegetables. Said he wanted to see if it would upstage all those pretty labels. Then he got back out of the way where customers wouldn't see him, to find out whether they would notice the painting. And I guess they did! Almost everyone had something complimentary to say. That pleased Andy. He thinks plain everyday people are the best critics.

"He gave me a painting, too. Would you like to see it?"

Fales led me over to his house next to the store and ushered me, almost reverently, into the room where Wyeth's painting of his dog Rattler hung. We looked at it silently. Fales handed me a guest book to sign. Hundreds of signatures preceded mine. I wrote and thanked him for letting me see the picture.

He said nothing, but I could tell that Irving Fales considered himself a very privileged man.

FORREST WALL: THE MAN FROM MAINE

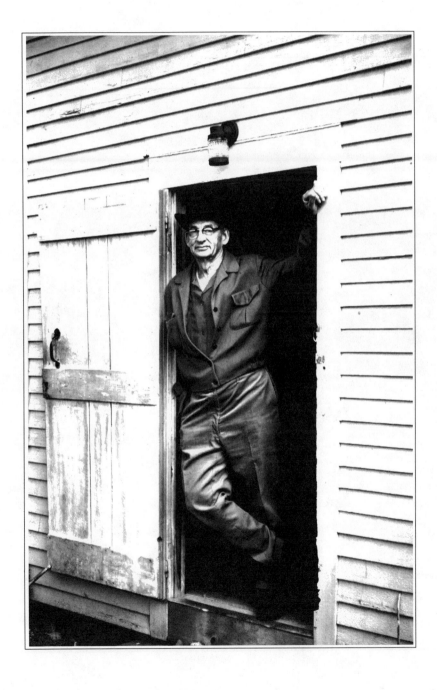

That evening I ate supper again at Our Place. Mrs. Celia Robbins, the only one at the restaurant who had shown any interest in my writing project, took my order and asked me how my story was coming. I told her I had called Wyeth, but that he had been unable to visit with me. She smiled, nodding. "Andy says the only way he can get his work finished without making everyone angry with him is to be sure he is unavailable." "You know him very well?" I asked. "Oh, I wouldn't say that," she said, a little too hastily.

She told me about other writers who had tried and failed to gain an audience with Wyeth, mentioned a couple by name, asked me if I knew them. Both were unfamiliar to me. She asked me a lot of questions and only much later did I find out that she was actually giving me a sort of third degree, trying to make up her mind whether to help me or not.

She brought me an article she had written, a whimsical story about an old wood cookstove. It was pretty good. Her sister, it turned out, had a few things published, and she herself, now that her family was raised, wanted to try her hand at writing. I told her there was only a small market for

the kind of piece she had written, but that didn't mean it wasn't craftsmanlike.

She also made a hobby of analyzing handwriting, she confided. I submitted to a test. She analyzed. She had me down cold. It was almost frightening.

The next day, after lunch, she shoved a piece of paper alongside my dessert. "If you wish, you can follow the directions I've written down and talk to a man who knows Andy Wyeth as well as any person alive. He's my father. You're invited for supper."

Then she smiled, and went back to work. Shades of James Bond, at last. I looked at the paper. The name written there was Wyeth's *Man from Maine*, Forrest Wall.

I do not know how to capture Forrest Wall with words, the way Wyeth has done with paint. He shifts gears too fast, this man of gentle perversities, this blend of attitudes and outlooks that are not supposed to blend. Wyeth, with the deft simplicity of genius, has painted him accurately, but no one could know that, not knowing Forrest Wall. Those who do not know, think of the painting as a symbol of all Maine men, but Wyeth meant something much more. Forrest is a very particular man from Maine. There is no other like him.

Forrest Wall is a farmer who can talk like an erudite scholar—if he has a mind to.

Forrest Wall is a young rebel, but he is also a great-grandfather.

He heats his home with a cast-iron wood-burning stove fired with his own fuel, cut and split by his own hand from his own woods, and he decorates the ceiling of his carpentry shop off the kitchen with centerfolds from *Playboy* magazine.

"Someone's always getting a stitch in his back looking up

there all the time," he says. "And the more they disapprove, the sorer their necks seem to get."

Forrest Wall is a farmer but more than a farmer: a carpenter, a teacher, a surveyor, a horticulturist, and a forester, too. "In Maine," he says, "you have to be good at five trades anyway, just to survive."

He is a true intellectual who all his life has had to work hard with his hands.

Wall is a man of religious sensitivity, yet he spurns formalized religion and despises dogma. "Rigidified" is one of his favorite words—"if it isn't a word, I just made it one"—and he uses it with scathing devastation: "When a man cuts a path through the woods, it is the natural tendency for others to follow it. That's all right. But the fiftieth man is very apt to believe that path is the only way to get through the trees and pretty soon he is telling his children they *must go* that way. He gets rigidified. Then he becomes dogmatic: in religion, in science, in art. Sheep are very good at dogma. And clams are better. They know only one way to live, in their little shells, stuck in the mud. Rigidified."

Forrest Wall is a consummate artist, not only with his hands, as a craftsman, but with his mind, as a philosopher. He has made an art out of life itself, as his daughter Celia likes to say. He is successful in living the way he wants to live. On his little farm he is practically self-subsistent: his own food to eat, his own fuel to burn, his own skill to keep a roof over his head, his own invisible wall bulwarking his lifestyle from the inanities of the rat-race world.

But there is no trace of the hermit in him, no drawing back from people. He turns quickly to look out the window at every car that passes, the trait that charmed Wyeth until he finally painted Wall in that stance. "When a car passes on this back road, it's a Current Event," says Wall.

He gathers every bit of news for miles around, but what comes in his ears goes out his mouth with calculated purpose. He uses gossip the way a doctor uses strong medicine, a dose only when it will do some good.

He is involved constantly in local activities. Pearl, his wife, told me in a letter, "You'd be surprised how many little acts of helpfulness that man of mine manages to crowd into a day despite all the other work he is doing. I don't hear about them from him, but later the recipients spill the beans. Today, with some real cold weather coming, he took time out to haul fir branches to bank the widow's trailer home as one of his 'boy scout' activities."

"Very few people really know Dad," says Celia. "He talks a lot, but he knows how to use talk. He says there are two ways not to show your hand. One is to keep your mouth shut, and the other is to say so many different things, nobody is quite sure what you said. He thinks the second way is much more fun."

When you eat in a restaurant with Forrest Wall, he will inevitably excuse himself, and make the rounds of the other tables. There are always people there he knows, or if not, people he thinks he knows, or if not, people he thinks he should know.

He is happiest when he can flirt with a pretty girl, and he can charm the ears off a stalk of corn. "See, being an old man I can get away with it," he chuckles. "Which is a terrible mistake. Nobody seems to realize how dangerous old men are. I think it is the way nature plans it. The closer the threat of death, the greater the urge to increase and multiply." He grins roguishly.

"If you scar the bark, or cut away strips of a fruit tree to the point of half killing it, that tree will produce fruit earlier than an uninjured tree. Nature in the face of death moves

quickly to increase the species. The older you get, the prettier they look. Ah me, what a shame." And he winks at Pearl and calls a waitress. "Think I'll have another helping of clams as long as this Farm Journalist is paying for them. You know, you can't ever starve a Mainiac out. He can always go and dig himself a bucket of clams."

But what Forrest Wall is most of all is Andrew Wyeth's friend. He cocks his feet up for warmth on that ancient wood-burning stove of his and talks about Wyeth—all night, if anyone will hang on that long and listen.

Not because he's known Wyeth since the painter was a child, not because he built Wyeth's Maine house, not because he's been a subject for many of his paintings, but because he loves Andrew Wyeth.

The family gathers round; Pearl takes a fresh pumpkin pie from the oven; Marge stops by; Celia drops in. Marge's son, who works with Forrie in the woods, comes to the door. "Oh no," he moans. "He's talking about Andy again."

"Andy's an independent cuss," Forrie begins, "if there ever was one. *He's* not dogmatic. And he doesn't follow anybody's wagon ruts. He hardly went to regular school at all, and that's what saved him. Andy and me, we went to Northeastern University—that's down in Massachusetts—once when they gave him an honorary degree there, and Andy leans over to me and whispers: 'I feel guilty as hell sitting up here accepting this thing in front of all those kids who have to work for it.' 'Ayuh, Andy,' I told him. 'But if you had to go through what they are going through, you'd never be up here right now.'" Forrie lights his pipe, pulls the stove door open a little wider.

"Andy thinks for himself. Only way he gets what he gets. He never paints that cute or picturesque stuff other artists do. Just look at my lopsided old face, if you don't believe it.

When Andy painted that rock over in the sheep pasture in Cushing, he even painted in the line of wool grease left where the sheep rubbed against the stone.

"I asked Andy once why he didn't paint a rainbow or something pretty and he said, 'A rainbow's nice enough just the way it is.' And I said, 'You'd paint a cow flap, wouldn't you?' and he came right back: 'Yep, if the light was right on it.'

"I'll tell you another thing that makes Andy great. There's not an artificial bone in his body. The whole area he works in isn't any bigger than a township and Andy really *knows* that area. You blindfold that man and put him under an evergreen tree in Cushing and he'll tell you whether it's a spruce or a pine by the sound the wind makes blowing through it."

"How did you get to know Andy in the first place?" I asked.

"Eventually if you sit tight in Maine, you will meet everybody worth meeting," Wall said. "They all get here sooner or later. When N. C. Wyeth started coming up here he acquired a big old summer house at Port Clyde, and I did some carpentry work for him there. One thing led to another. Pretty soon I was making picture frames for him and we were baby-sitting with the kids. I watched Andy grow up.

"He was about like any boy. A little sickly, though. He wasn't exposed to the same environment most boys are. He was tutored at home mostly. His father did most of the teaching and training, though old Cris Sanderson at Chadds Ford was Andy's tutor. Andy was around older people a lot. But he lived more of a make-believe life than even ordinary boys do, because the whole family did. Pa Wyeth made Christmas a real stage production, and those kids always had the best toys to play with.

"Andy went after drawing and painting like a duck to water. He just seemed to know what his nature was. But even at an early age, public things made him nervous. School made

him nervous. Did you see him on television a couple of years ago? See, that's just godawful to Andy. He likes to watch from the corner. Did you ever think that Andy is kind of a human television set? Reality runs through him and comes out so the rest of us can see it easier.

"When Andy and Betsy were first married, they weren't affluent, though people think they were. We started to build their house over on Betsy's father's place here, and we ran out of money long before we ran out of lumber. We were sawing up a spruce log that I wanted to use for the house and Andy said, 'Hold it right there. I think I see how I'm going to pay for some of this.' And he commences to paint. That happens when you're around that painting fool. He gets an idea for a picture and all other activity comes to a screeching halt. So there we were, poised over this damn log while Andy paints, and telling us not to fret. We were getting fifty cents an hour and not sawing through one log in two weeks. I couldn't see any arithmetic in that. But that painting was *Spruce Timber*, and he did sell it and up went another wall.

"One day we get a call from up Penobscot way from Red Kellogg—Reverend Kellogg. Seems there was some lady coming through from Chicago who had a powerful urge to acquire Art, and if Andy were to bring something up, well, there might be a sale in it. Betsy said she couldn't go, and Andy said if she wouldn't, he wouldn't either. He didn't want to go up alone. So I said, well, how about if I go along? Even a working man ought to get a day off once and a while. So Andy and me, we went.

"You have to watch that Andy. We got up there and things were going just fine. Andy had paintings spread all over the floor and this gal was looking them over, and whichever way she felt about a particular painting, well, Andy he felt the same way.

93

"When she oohs, he aahs, and when she clucks, he sighs. If she sees blue moods in the sky colors, he sees blue moods in the sky colors. When I hove in sight, Andy spits and polishes me up to his customer and introduces me: 'This is Mr. Wall, *The Wyeth architect,*' he says very impressively, the devil just gleaming in his eyes. Well, I came right through that one okay, as I could talk architecting right along with Frank Lloyd Wright, if I had to. As it turned out, we could have sold funny papers that night. The tide was really rolling in and I could just see the chimney going up on Andy's house.

"Later there's a party and when we sat down to supper late, Andy's at the other end of the table and he has his head up close to Kellogg and there is that look on his face and I thought, look out, what's he doing now? Finally the reverend clears his throat and addresses another respectable-looking gentleman about halfway between us. 'Dr. Spencer,' he says, 'have you met Professor of Psychology Wall of Princeton?'

"Andy has his head buried down in his soup someplace as I manage a scholarly nod or two. But Spencer, who turns out to be from Harvard, is puzzled, as well he might be. I could just see his mind running down the roster of psychology professors in the Ivy League. Finally he asked me, politely, if I knew Dr. Holt.

"Now that was the biggest piece of luck to hit me since I met Pearl. Dr. Holt I did know, about the only professor of psychology I knew in the whole wide world. I built some bookshelves in his summer house, not too far from here. 'Let's see,' said Spencer, drawing at his chin, 'I'm not too familiar with Holt's work.' 'Well, he's a champion of determinism, I believe,' I said in my most authoritative voice. I'd discussed some of that stuff with Holt before. I was watching that rat Andy, and he was kind of all hunched up, shifting around on his chair. Spencer was still probing. Next he

wanted to know what books Holt had written, and again it just so happened that the only book I'd ever read on psychology was Holt's *Freudian Wish*, or something like that. I forget now. Anyway, I reeled that off nonchalantly. About that time Kellogg said something airy about determinism and he and Spencer got into an argument. That saved me. When we got back to our room, that damn Andy just laid there on the bed and squealed in delight.

"He pulled the same thing on me when a reporter from *Newsweek* called him after *Man from Maine* sold. Wanted to know all about me, and Andy, he figured the guy must be a stuffed shirt not to ask me personally. So he told the reporter I was an ex-professor of psychology, and damn if they didn't put that in the magazine. That just tickled hell out of Andy, of course.

"I wrote *Newsweek* a letter telling them I was a Maine farmer who kept alive digging clams out of the mud, and the only school of which I was an ex-professor was the school of ornery knowledge. I told them the average person knew more about applied psychology than the average professor.

"They were good sports about it. One of the editors wrote back, apologized, and added that if I were not a professor of psychology somewhere, I ought to be."

Pearl interrupted. "Steve Etnier bought the painting of Forrie. Mrs. Etnier said Forrie looked so real and alive that it almost seemed embarrassing to hang the painting in their bedroom, and Forrie told her, 'Don't worry, I won't ever turn around.'"

Wall recharged his pipe, then continued:

"Andy is a perfect example of don't-give-a-damn innocence. He went to a restaurant one night with those white pants on he wears all smeared with paint, where he wipes his hands and brushes. He wipes his brushes on his lip sometimes too. It was

a pretty fancy place but they let him in. Andy wanted to dance. He was told to sit down. Andy sat down. He figured he could wait that big chief out. After a while, he starts dancing again. And they threw him out. Andy thought it was all great fun. See, he is so damn confident, you can't insult him. They'd have bought him a tuxedo if they'd known who he was.

"One thing Andy is not, and that's elegant. He'd probably get the award for the worst-dressed man in the country, if they had such a contest. One time at some big doings we were at, Betsy and he were supposed to attend a fawncy dinner in evening clothes with all the trimmings. They hadn't brought along anything like that, but they scrounged around and borrowed some clothes. Andy came out triumphantly in his borrowed tuxedo. It was holding him back a little, but he was staying on his feet. 'How do I look?' he asked. He raised up the coat, and showed me how he had the oversized pants hitched up with some big horse-blanket pins.

"When he first bought that big Continental, he drove it up to a gas station and the attendant thought he was the chauffeur. 'I heard they bought a Continental,' said the station attendant. 'How's it like, being a chauffeur for the Wyeths?' 'Pay's awful,' Andy told him, 'but you get to meet a lot of odd people.'

"There's lots of stories go around like that. Never know how true some of them are. One goes that Andy came into a shoe repair shop to get one of his outlandish pairs of shoes fixed, and another customer came up to him, a woman, and says: 'The clerk down there says you are Andrew Wyeth.' She looked over his bedraggled appearance in disbelief. 'Is he putting me on?' 'No, I'm Andrew Wyeth.'

"She sniffed. 'Prove it. Draw me something.' So he got a paper sack and sketched her camera perfect, handed it to her, and walked out the door.

"But there are times when this business of identity works the wrong way for Andy. Offshore here, there are lots of little islands privately owned. Now, a man who pays good money for his own island is almost always a lover of privacy. He doesn't like people very much. Well, Andy went ashore on one of these islands and began to sketch. The owner came storming down and told him in no uncertain terms where to head out. Andy tried to cajole the fellow, but without any luck. Finally, as a last resort, he said, 'Do you know who I am? I'm Andy Wyeth.' 'I don't care who you are, get the hell off my island.' Now, that's Maine for you."

I told Forrie that I found people in Maine to be as hospitable and outgoing as anywhere.

"Yes, but we have to try to keep up our image," Forrie said. "It's hard to figure Mainiacs. We vote one way and drink another. We call summer people summer complaints, but of course our whole economy is built on them. What we mostly have against summer complaints is the way they question our manner of doing things. They all know better ways, and we have to put up with them until they've been here long enough to find out we know what we're doing. Why, some of these people talk about bringing industry up here, the very thing they came to get away from."

Wall put another chunk of wood in the stove, sat down.

"It is pretty plain to me that most of the problems this country has could be eased down to size if only we controlled population. The time when big families solved problems is gone, but people are rule-making animals. Rules should have built-in obsolescence but they don't. We make the same mistake in religion and art. When science accepts a creed, it commits suicide. That's why the critics have a hard time putting Andy in a slot someplace. He didn't read their rule books.

"Andy would make a damn poor scientist. He's got very little gift for generalizing, or making lists of things the way a scientific mind does. What I mean is this. Say he goes walking through the woods, and he may know all the names of the trees he passes, but he never consciously says, 'I am going to learn the names of all the trees that grow in Maine.' He might watch birds, or a bird, but he never becomes the birdwatcher trying to make up a life list of all the birds in eastern America. His mind doesn't go that way. I can't imagine him, no matter how many swamp oaks he found growing on poorly drained land, ever saying: 'Swamp oaks grow only on poorly drained land.' He'd know that probably, but not explicitly. A particular swamp oak, on the other hand, might catch his attention—the form and color of it.

"Like Christina Olson. There was a woman came up here from New York and she just went on grandly about Christina and *Christina's World,* how this courageous, stalwart daughter of the hard Maine soil represented all Maine women pitting themselves against the hardships they lived with and surviving by their pluck and hardy pioneer spirit. And all that blah-blah. Now, believe me, that was not Andy's intention. He was painting Christina Olson, not some far-flung generality. There aren't two Christina Olsons in the whole wide world, as far as Andy is concerned. Sure, if he'd lived somewhere else, he might have found another unusual woman to paint just as well, but that would have been some other woman, not Christina.

"Andy paints Negroes, and many people today try to figure out some disguised statement in his work about racial prejudice. Andy doesn't paint moralizations. Moralizing is almost always generalizing, and generalizations are almost always wrong."

"I've heard," I interposed, "that Andy used Betsy as a model for *Christina's World.* "

"That's a common error. By the same reasoning you could say he used me to pose for Betsy in that picture of her sitting on the beach—*Sandspit*, it's called. When he had the painting about the way he wanted it, he had me pose in that shirt she was wearing, because she was busy one day, just so he could get the folds of the shirt and the way it was rolled up above her elbow. He kept shaking his head and saying, 'Boy, you sure ain't Betsy.'

"I've done a lot of that kind of posing. In the painting of Waino Matson digging the grave—you ought to know Waino, he lived in that shack down at the end of Andy's driveway and he did odd jobs and always wanted to own a boat—anyway, Andy had to talk pretty good to get him to pose, and Waino said finally he guessed it wouldn't hurt his feelings any. But he couldn't take that kind of work, standing there holding the shovel, while Andy painted, not getting anything done except making wages.

"So after Andy got his head painted, I substituted for Waino. That's his head and my body. They hang together pretty good, I'd say.

"But to get back to Christina, there really wasn't anybody quite like her. Going to Christina's house was not a very pleasant undertaking. She couldn't keep that house clean. Marge did a story on her. It smelled to high heaven in there and she was glad to get out. But Christina was doing the best she could and she did not want any help. She lived the way she wanted to, and if she'd wanted better care or a wheelchair, she would have had it in a second. But now, here's Andy. He didn't smell anything, or at least it didn't bother him. He never offered any help. It didn't matter to him that the house was dirty. *That's the way it was.*

"Someone asked him once, 'Andy, why don't you help those people out, they're in a bad way?' 'Oh, they are?' said Andy. 'I

never once heard anyone in that house say they needed help. I heard quite the opposite. And I know people in very fine houses who are in a lot worse shape than Christina and a lot less sensitive to the beauty around them.'

"You have to understand that about Andy Wyeth. He accepts reality while the rest of us are trying to make dreams come true. You will never ever hear him complain about the weather and he's out in it a lot. What good would it do? The weather is there. That's the way it is. If it's foggy, he'll paint fog; if it's windy, he'll paint the wind, and, by gosh, he can paint wind, too, if he has the notion.

"Andy was painting some sea gulls at the base of a lighthouse and the painting only took in about half of the tower. Andy wasn't interested in the lighthouse. He wanted to paint the uneasiness we feel for men who are out on the water when a storm drives the gulls in like that. But two women passing by paused to look at the painting. 'Look at how he cut off the top of the lighthouse,' one remarked. 'Just like an amateur,' the other sighed.

"Andy is so sensitive, he will run away from you rather than hurt your feelings. I've seen him, while painting, endure in silence interruptions from inconsiderate observers. Once he did lose his patience and that time it backfired. He was painting a cemetery and church, the picture called *Perpetual Care*, and a woman stopped her car right in the way. She came up to him and kind of jigged around impatiently in his line of vision. Finally Andy stopped painting. 'Do you think you could just please wait a few more minutes and I'll be through,' he said sharply. The woman glared at him. 'I *just* came here to put some flowers on that tombstone you're painting, sir.' Well, Andy felt so bad, he waited till she put the flowers in place and he painted them there, though he didn't have that in mind before at all."

I said that I felt a nearness of tragedy or sorrow or loneliness lurking around the edges of some of Wyeth's paintings, and was struck by the fact that the hill of *Winter 1946* was adjacent to the railroad track where N. C. Wyeth was killed. That reminded Forrie of something. He fished out of a big chest of family memorabilia his copy of the book of Andy's paintings. He turned to *The Wake*. It shows only a boat coming head-on in a slate-gray ocean. Is there someone in the boat? You can't tell. Only that there's something sinister about the whole thing.

"The truth is," Forrie explained, "a lobsterman fell out of his boat while running his traps, and the boat, motor going, got away from him. From Broad Cove Farm, Betsy saw the man swimming for shore and frantically called the Coast Guard and every fisherman in the area to come to his help. But no one got a boat to him in time, and she had to watch the man drown.

"Many lobstermen can't swim at all, you know. Reminds me of old Hen Teel—Andy painted him, you know. Pa Wyeth painted on Teel's Island, and Andy kept on—anyway, somebody asked Hen once if he could swim. 'No, don't reckon,' Hen answered. 'Well, don't you worry a little, being out on the water so much and not being able to swim?' 'No, don't reckon,' he replied. 'Better drowned than freeze to death.'

"The lightning rod Andy painted was on top of Hen's barn. Teel farmed the islands and fished in between them and did all right. He filled his barn with hay he made on the islands and boated over. Well, Andy got a feeling about that lightning rod up there. Figured that if parsimonious old Teel thought it was worthwhile having, it ought to be worthwhile painting. But he can't paint it like anyone else would. No, he had to crawl up on the *roof* to paint the damn thing. Hen was never completely sure that Andy was totally sane and when

he came in from his boat and saw Andy up there he shook his head sadly and said, 'There's that crazy feller up there with his slippery brush again and now my chickens are afraid to go to roost.'

"Andy painted Teel looking out the window. When he was inside, that's what he'd do, look out at the water. Even if he was out fishing all day, when he'd come into the house, first thing was to look out at the water. He listened to the news on the radio, but as soon as he got all the facts clear, he'd turn it off to make the batteries last longer."

"Does Andy fish or sail much now?" I asked.

"Not much anymore. About all he does is paint. Raised some tomatoes once just to prove he could."

Forrie starts dipping deeper into the chest. Soon we are paging through albums of photos showing Walls and relatives and Wyeths in various stages of growth. I asked why one never heard much about Andy's mother.

"Oh, my, in a houseful of artists you have to have someone to keep the ship steady. Only one thing I know she's outspoken about. You better not come into her kitchen when she's cooking. That's the unwritten law at the Wyeths'. Maybe that's where Andy gets his dislike of people watching him paint."

Wall fishes a letter from the chest, looks it over fondly. "Here," he says. "Read this. Andy sent it to me when I was in the hospital." Wall was trying to act nonchalant, but I could tell he was very proud of the letter. I read with interest, again struck with Wyeth's complete lack of self-importance. Andy had drawn a few sketches to illustrate restoration work at the mill. For him, pictures came much easier than words. Other than that, it was, "Get well soon, old buddy, and don't flirt too much with the nurses" type of sentiment—a typical letter any man might have written to a sick friend.

"Andy even dated that letter," Wall observed. "Normally he doesn't know what day it is. He hardly ever wears a watch, and if he gets absorbed in something, he loses all sense of time. I don't know how often I've seen the tide come up on him while he worked, and the water would be lapping up around his ankles and he wouldn't know it. I've rescued paints and brushes for him that the sea would have carried away.

"One day he was painting up in the belfry of a little country church. Painting *Toll Rope,* I think. Pretty soon, as he tells it, people started to come into church, the organ began playing, and it dawned on him that it was Sunday, and he had terribly old clothes on. He figured if he came clambering down out of there, he'd scare the congregation half to death, so he just stayed real quiet up there painting, and no one ever knew he was there. He said he couldn't ask for more atmosphere while painting the inside of a church steeple: organ music and a good fire-and-brimstone sermon.

"But when you're modeling for Andy he's aware of every little change you make. He wants you to talk. I tell him the same story maybe three times and still he laughs. If I fall silent, pretty soon he says, 'C'mon, say something. You're going dead on me.'

"Sometimes I help read the mail when it gets real heavy. That's an education. Andy could spend all his time just answering the people who want him shot or who want to marry him. But we try to get through all of it. Every so often there's one worth answering. You know, fame is a hell of a thing: the letters and phone calls and requests for interviews. But like Betsy said once: 'It's surprising how considerate so many people are, too.'"

Talk shifted to gardening and we swapped brags about our strawberries. Wall decided to take me on a tour of his little farm. From the carpentry shop, where some of the frames for

Wyeth originals originated, we walked down a hill to his gardens and fruit trees.

"To eat well is the first refinement of culture," Wall said. "And no one knows good eating until they have their own garden. It is so simple, even the poorest man can have the best food. The land begs to be hoed. It just takes the discipline of manual labor. Train yourself to that and you have licked the world.

"The surplus from my garden is priceless and it goes only to very special people. We used to make part of our living from selling garden produce. The kids would take it around and people who thought they knew vegetables would sometimes refuse our stuff because of its large size. 'That big stuff is not so good,' they'd say. But the kids were instructed to get them just to taste once. After that we had no trouble selling whatever we had to sell. The secret is making things grow fast. Once a vegetable starts growing, it must never have a day's lull due to lack of moisture or fertilizer. If you prevent that, you will have large, luscious food."

We passed a stack of cordwood. "I started to manage my woods like any other crop, turned the forest land into a registered tree farm and planted trees. People laughed at me. Now my grandson and I cut pulp wood this winter from trees I planted twenty years ago and made a nice profit.

"When I was young, I went through the First World War in France, and I had knocked around some before that. The war and all made me wonder whether mankind was really sane or not. My generation thought the power structure was going to pot, too. But I was immensely impressed with the small subsistence farms in France. Those peasants knew what they were doing, and even in war, they could survive. They were nearly indestructible because they lived on small units of land that were nearly self-supporting. If you turned the electricity

off on them, it wouldn't make much difference. But what really impressed me was that those little farmers weren't really working themselves to death, or heart-attacking themselves out of business early in the game. They were, in the main, a pretty happy, contented bunch of people. Someplace in one of those miserable trenches, I swore I was going to come home, get me a little place and try to live sanely, or starve to death trying.

"And that's just what we did, almost—starve to death.

"The first year back here I hung my hat on potatoes. I planted potatoes on every inch of ground I could turn over. I remember the price of the seed potatoes was four dollars a bushel and I had been making three and a quarter a day in wages. Anyhow, sure as God made little green apples, the bottom dropped out of the potato market that fall. Celia had just been born and it looked like a long cold winter. I got my rifle and went out in the woods and shot the biggest buck deer that ever walked on four legs, and we lived on venison and potatoes till the garden came in next spring.

"Little by little we got our heads up above the waves. There were tough times.

"During the depression I had such a crop of turnips and potatoes. We stored the cellar full. We ate turnips fried, boiled, candied, raw, two times a day that winter. We became experts at eating turnips, that we did.

"I find out now that when I was a kid we were living in poverty and didn't even know it. My mother was strong on two things: hard work and reading. As a kid I could tell you a good deal more about classical literature than I could about what it says on a dollar bill. We would have been Welfare today, but you know what Ma would tell us if we got to complaining about anything? She'd say, 'Well, one thing you can be thankful for: at least we're not poor.'"

RALPH CLINE: THE PATRIOT

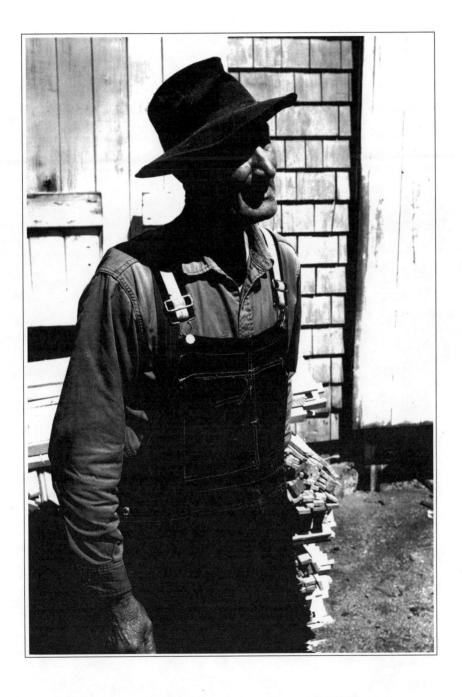

I knew that Ralph Cline, the lumberman Wyeth painted in his famous *The Patriot*, lived somewhere in Spruce Head, not far from Thomaston. I stopped at a little grocery store in that vicinity to ask directions. As I entered, two men were seated by the door on overturned wood crates. "I'm looking for Ralph Cline," I told them. "Does he live near here?"

A pause, then, "Ayuh, he does."

I waited for directions. None were forthcoming. An old Maine custom, perhaps, to answer only the question asked. I kept on waiting, just for the hell of it. Bought a pack of cigarettes. Waited. Nothing more. So I shrugged and accepted defeat. "Can you tell me where he lives?" Again, a slow yes and nothing more. Finally I pried Cline's whereabouts out of them. As I went out the door, I looked back. They were grinning at each other.

I drove up to Cline's sawmill, dwarfed by the hill of sawdust beside it. Of the two men who were running logs through the saw, I knew the old one was Ralph Cline. He hailed me loudly as I walked up.

"I'm looking for Mr. Cline," I shouted above the saw noise.

"You found him for sure," the old man roared. "I'm Cline, that feller over there is Cline, and there's a couple more of them down the road. The woods is just full of Clines today!"

He came out of the sawmill, his hand extended, just a bit of a smile on his face, studying me, eyes half hidden under a slouchy old felt hat, bib overalls brand-new. "You came to see the Patriot," he volunteered. "Well here the old cuss is." He whipped off his hat, exposing that bald head, which in the painting seems large and imposing enough to represent the earth itself. But is was just like any other bald head, white above the hat band, where the sun never hit it.

I told him he was right, and introduced myself. There was about him an air of patient duty, as if he felt that since Wyeth had painted him into the public eye, he owed it to the community to hold up his end of the bargain and entertain when the public demanded it.

"You live around here all your life?" I asked.

"Not yet," he shot back. I was off balance. When in doubt, grin. I almost grinned my teeth loose.

"How's the lumber business?"

"Better than it might be, worse than it could be. Like the farmer who had a pig to sell. He didn't know how much it weighed, but figured it was even less than that."

"You a farmer, too?"

"No, thank you. Farmin' ain't one of my weaknesses. My nephew gets your *Farm Journal*. He knows farming inside out and he's a good businessman to boot, but he'd sell out in a minute if he could get his money out of the place. Farming has got the conglomerating fever. Big dairies swallowing up little ones. And I know how that goes. Pretty soon we'll be getting chalk instead of milk. Already some of that stuff they sell tastes like water the cow breathed on."

All this was said, had to be said, in shouting voices, above

the whine of the saw. I ask Ralph if Wyeth had painted him here in the sawmill. "Right up above here," he said, pointing. "Come on, I'll show you."

He led me at a surprisingly frisky gait for a seventy-four-year-old, through the mill and up some steps along the back wall. On the second floor was a chair—and a window. "Right here is where I sat six weeks, looking out that window," he said. The position of the four legs of the chair was marked in pencil on the floor. Ralph moved the chair onto the little penciled squares, sat down, and gazed out the window. "Just like this," he said proudly.

Some of the excitement of raw creativity that Wyeth must have felt, touched me. The dark, dusty room, hidden away from everyone, the light streaming through the window doing things to Cline's craggy face that would excite the most amateur photographer, the bald head resembling, as Wyeth had observed, the bald head of the American eagle . . . the old patriot, now far from the volley and thunder of war (though the saw downstairs screamed like a wounded soldier), he the Patriot, the old man with a dim memory of victory and Armistice and ticker tape streaming down, sitting in this dusty sawmill loft.

On the wall was tacked a newspaper article about the death of Sergeant York. I read it.

"*There* was a man," said Cline simply.

"Did you know him?"

"Not personal, but I guess you'd say I strived to be like him."

"What would York have done about the draft card burners today?"

"Be enough Yorks around, there wouldn't be any draft card burners. But don't get me started on that. I'd rather not talk about it. I might lose my temper."

"Did you get bored sitting up here all that time while Andy painted?"

"No, not at all. We talked a good deal. Deep down someplace, I'd venture that Andy and I have something in common. Andy is much more than an artist, in my book. Art is just the way he makes his bread and butter. We all got our ways and one is about as good as another if it's honest.

"But Andy runs deep without even trying. He's at home with highbrows but he can just as well sit down at my plain table and eat my plain food and talk my plain language. Other visitors can do it too, but you can tell they're straining. Not Andy. Andy and me ain't so different, underneath.

"I left home at thirteen. Been on my own ever since. Worked first in the harvest fields of Aroostook County. In Aroostook you earn what you get, I tell you. Worked in the big woods, too, and on steamboats. First good job I had was as a steam engineer in Detroit. But the war came along and I got into that and started really learning something then. I ended up at Meuse-Argonne. I was a sergeant. A sergeant draws an awful lot of water in this here Army, don't you know it. Well, I don't like to fight, but I *can* fight.

"I lead the veterans' parade every year on Memorial Day. That's how Andy first saw me, leading the parade. Well, I've led it every year for twenty-three years and I'm proud to do it. But people say I'm a warmonger, a flag-totin' American Legion type warmonger. Well, I'll tell you something. There ain't anyone against war like this returned veteran. But now I'll tell you another thing. This man's world ain't come to it yet, where you can solve problems with a blue-eyed offering of love beads, either.

"Tickled me. Part of the Memorial Day event is to recite some songs and poems and such. We always use *Flanders Field*. I like that poem. Last year the woman in charge of things, she

comes and asks me what I think . . . should we keep *Flanders Field?* She thinks it is too warlike. Now, that is something. Too warlike. What she think we are commemorating, a tea party?"

Cline beckoned me to his desk. "Want to show you a write-up," he said. "About my porcupine war." He couldn't find the article. "Well, anyway, to get back to that *Farm Journal* of yours, you tell them we have a heck of a problem up here. The porcupines are taking over. There's only one good thing you can do for a porcupine. Shoot it. Now, I'm against poison sprays and against water pollution, and *for* conservation, so you might wonder why I say that. Well, we got porcupine pollution. They are eating all the trees we plant. Biggest trouble is the state won't pay bounties anymore. *I* still pay a bounty on the rascals, five dollars each right out of my own pocket."

"You still planting trees at your age?"

"Sure. The right way don't get to be the wrong way because of a man's age. Anyway, I knew there was a bunch of dens full of porcupines in a great big rock pile, so I took care of them. I dynamited the rocks. Figured at least it might scare them into sterility. Pretty good form of birth control, don't you think?"

"Forrie Wall says you organized a militia during the war in case the Germans attacked."

"Forrie telling you his stories, eh? Well, there's truth in 'em. You know, we had a German submarine come in once. Let two spies off, but a couple of our boy scouts caught 'em. You don't mess around with us Mainiacs, not even the young ones. Well anyway, we just knew there was German U-boats out there and why shouldn't they get a high-minded notion of landing a force on our unprotected coast and working their way down to Boston? So I got the boys together and I told them we wouldn't have a chance of stopping the German

Army if they did invade us, but we could sure annoy the heck out of the so and sos when they came through.

"We did a lot of practicin' and the boys were getting the feel of battle tactics. They were pretty good at skirmishing, but not on regrouping. The first day I was a little tough on them, I guess. I chewed them out good for not listening to orders. So the second time they were supposed to fall back and regroup, the blue-eyed babes all sifted into the pucker-brush and went home."

By that time I was laughing uncontrollably. He changed the subject. "I know your magazine. I believe I have a cover that Andy's father did for the *Farm Journal*. Let me see if I can find it."

He came back from the house with a cover from an old *Country Gentleman*, published for many years by Curtis. On the cover was a Thanksgiving scene: a big turkey in the middle of the table and three children saying grace, but the smallest boy's eyes, under his bowed head, were riveted wickedly on the turkey.

"That's Andy gleaming at the turkey and that's Carolyn on the other side. The one in the middle is probably Andy's older brother, but I don't know for sure. See how Andy eyes that turkey when he's supposed to be praying. His dad knowed him good.

"Betsy spied this cover," Cline explained, "in a heap of old magazines. She pounced right on it. Knew it was an N. C. Wyeth. She's a scavenger, that Betsy is, with the eye of an eagle. And when she's got her curiosity up, she'll go anywhere a mountain goat will.

"You should have seen her the day when them TV people was shooting my picture. They were doing a TV show on the people Andy painted. Well, I'm no gosh darned movie star, and here they were with cameras bearing down on me and

men running all over the place and I was supposed to act
normal. If I'd acted normal, they'd never been able to show
that picture, at least not with the original sound track. I don't
mind sayin' I froze up on them. So they got Forrie Wall down
here, and Forrie, he's a whiz-bang at this sort of thing. He did
the whole part on being a Maine lobsterman for them, and he
ain't caught a lobster in forty years. Well, Forrie, he whispers
to me on the side that Betsy is comin' over to keep an eye on
things and if we were to see a little old lady in sunglasses
doing her knitting nearby, that would be her. So I felt a little
better, and Forrie got to talking about the war and we were
discussing pine lumber up one side of the tree and down
another, and the cameras are going and the men all pleased
and thank you kindly, when here comes this big black Conti-
nental oozing up into the scene. Now, when you are trying to
picture the genuwine backwoods Maine sawmill, a Continen-
tal doesn't hardly blend in very well. So the big chief he goes
over to Betsy getting out of the car and says, 'Look, lady,
would you mind just pulling back out of the way some. We
are doing some scenes of Andrew Wyeth's country.' Ole
Betsy sort of arched her back up a little and leveled: 'Sir. I.
Am. *Mrs.* Andrew. *Wyeth.*' That sank 'im. Oh, I did laugh. I
did okay after that. I. Am. Mrs. Andrew. *Wyeth.* Whoooee.
Get Forrie to tell it. He can say it better than I can. They got
a pretty good film out of that though, even after all that
fluster-botchin' around."

"What do you make mostly from your lumber?"

"All kinds of things. Lots of lobster traps. See all these
bundles of slats. That's what they're for. Lobsterin' ain't so
good right now, but you can never tell. Lobstermen are like
farmers. They complain a lot and lie all the time. Never be-
lieve a lobsterman. Business is always bad and getting worse.
But now when the government says that lobsterin' works out

to about eighty percent profit, that's a bunch of bull. Some crazy economizer down there in Washington that never got up one day in his life at four A.M. like a lobsterman has to do, figured *that* out on the back of a napkin during one of his forty-five-minute coffee breaks.

"We got a lot of people living in this country who have nothing else to do except make up rules for the people who do have something to do. That's prosperity. When you got so many people you can only keep about half of them employed at anything really useful. Prosperity has ruined more people than poverty ever could.

"And now they want to bring more industry into Maine." He stared away. "The cranberry marshes mostly all gone now, and the wild strawberries. Probably those chemicals they been spraying. But they always said that wild strawberries follow where horses graze. No horses anymore; no strawberries. And how I love a strawberry. God could have made a better berry, but He never did. Oh well. Maybe they'll come up with a chemical to shorten the lives of them blasted porcupines that's eating up my trees."

GRAPE WINE WITH WILLARD SNOWDEN

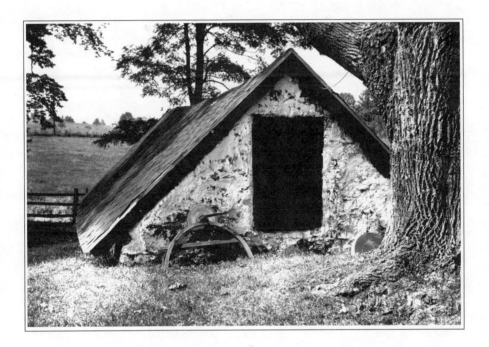

\mathbf{B}ack in Pennsylvania, I became a local fixture at Chadds Ford. I drank gallons of coffee at Hank's, listening. I learned every twisting back road in the area, and continued to discover places Wyeth had painted. I found the old brick house on the edge of town that became *Tenant Farm*. Someone told me it was there along the road, yet, with the painting in mind, I drove right past it the first time without recognizing it. That is how different the real house appears from what some have called the "photographic" painting of it.

Sometimes a seemingly aimless trail ended in an interesting bit of Wyethana. Driving north toward West Chester, I spotted Bill Baldwin's Book Barn, an old country barn that he had renovated for a bookshop. I stopped.

Inside, Baldwin and I jawed about old books, new books, and especially books illustrated by Chadds Ford artists. He had several for sale done by N. C. Wyeth, Frank Schoonover, and Howard Pyle. There was even one from the middle thirties illustrated by Andrew Wyeth, which must have been one of his earliest efforts. The illustrations were line drawings, which I found very uninteresting. (Three days later, when I

changed my mind and came back to buy the book, it was already sold.)

"I managed Andy's first show in Wilmington, you know," Baldwin said. I snapped around and almost startled him. "Yes," he said. "It was a complete bust. We had our gallery then on Shipley Street. The directors from Dupont could almost look right down from their board room into our windows, and we figured, well, if anyone was going to buy, we were in the right place. Andy had made a real success of his first showing in New York in 1937. He was only twenty years old and sold the whole batch.

"Well, this was 1941 and this was Wilmington. Andy had about twenty watercolors and drawings of Brandywine views to sell. So Andy and I rolled out the publicity and had the show. Even served tea. Joseph Hergesheimer, the writer, was there too. But we sold nothing. After Andy's show, I exhibited some duck paintings by Churchill Ettinger. Well, the gentlemen came over from the board room and bought those. Five the first day! They were all duck hunters, you see. We didn't sell a single Wyeth, with all of them priced between two hundred and four hundred dollars. What they would be worth today," Baldwin said with a sigh. "But you know what Andy's comment on the whole sad affair was? 'I should have painted a bunch of ducks, I guess.'

"Andy's a fine person, he really is. You'll hunt a long time to find anyone who knows him denying that. I was just down there the other day over a little business. Andy has this thing about apple cider. He loves it. He loves to take people down to his barrel and give them a swig. I like cider, too, but a lot of people will take a drink out of politeness. The Wyeths still have an orchard, you know, his father's orchard, over above

his studio in Chadds Ford. They say his father, N.C., always thought he wanted to be a farmer."

Serendipity sometimes failed me. One day, on the road to Wilmington, I remembered that the businessman and art collector William Phelps, who lived in Montchanin, the area I was passing through, was one of Wyeth's first patrons, to whom Wyeth had written many letters. Perhaps I could get to see the letters. Nothing ventured, nothing gained.

But when I found the Phelps estate, I realized I was hardly dressed for surroundings as baronial as these, at least not without a briefcase full of letters of introduction. Should I retreat? Never. Assuming my own peculiar air of non-chalance, which has always been my prelude to disaster, I knocked on a door, and addressed myself to the very correct Negro who answered.

"Is Mr. Phelps at home?" I said jauntily, peering past the man as if I were a bit annoyed at being so detained.

His eyes, which had been traveling critically up and down my bargain-basement shirt and pants, now leveled. Just the slightest smile touched his face. "Yes, sir, he surely is. Buried here, sir, these past two years."

In all my comings and goings around Chadds Ford, I saw Wyeth often, from a distance, but I gave him a wide berth. There were times when I know I could have moved in and made the writing of this book easier, but some kind of block-headed pride prevented me.

I wanted to meet Willard Snowden, the man the world knows as Wyeth's *The Drifter* and the subject of *Grape Wine*. During the winter and spring, he lived in Wyeth's studio in Chadds Ford and I hoped to catch him there alone. One day, I

saw Wyeth's car over at Kuerner's, so I sped on back to town, parked, and walked down to the studio. I felt more comfortable approaching the man on foot than barging up in a car.

But when I rounded the corner of the studio, there was Wyeth standing on the porch with a bunch of brushes in his hand. Somehow he had returned ahead of me. I braced myself for a Wyeth Disappearance Act. Instead, Wyeth bounded off the porch and shook my hand warmly. "I read your story,* and I liked it very much," he said. "In fact, that's about the best thing written about me yet."

My mind went stone blind. I thanked him and said something immensely original about the weather. He thought it would get warmer. "You know, for some reason, you scare the hell out of me," I admitted. He laughed. "Don't ever feel that way." Then he grinned. "I doubt you'd say that if you really were." He said they had gotten quite a bit of mail from the article. I told him that one woman, looking at the print of *Christina's World* and the photograph of the house alongside it which we had used to illustrate the article, had written: "I have that print of Christina. But I've never seen that other painting. I like it even better." He laughed. I told him I'd seen his car over at Karl's house, and thought it would be a good time to talk to Willard while Wyeth wasn't working in the studio.

He called Snowden from the house and introduced us. Wyeth said that he hoped the article would do me some good. There he was, being practical again. I mumbled something about not caring about that, only that I wanted the little people of the country to know him.

He seemed totally unimpressed. I wasn't being completely honest and he knew it. *I* hoped it would do me some good too.

* "Beholden to No One," *Farm Journal,* March 1969.

122

Willard ushered me into the kitchen and Wyeth went into the studio. I felt boxed in. If Wyeth was going to sit in there and listen to every word I said, I just couldn't bring it off. Interviewing anyone, but especially someone as difficult as Snowden, was a very personal thing, and a third party, especially *this* third party, would kill my kind of conversation. It struck me that I was feeling the same kind of reluctance Wyeth must feel when people watch him painting. The third party can destroy the kind of rapport that might lead to art. If Wyeth sat there and listened, all my blandishments, all my ignorance, all my tricks, the whole *art* of interviewing would look like a great, awful neon billboard flashing on and off: Logsdon is picking Snowden's mind; Logsdon is trying to get Snowden to say something interesting about Wyeth; Logsdon is a sneaky s.o.b. For the first time, I began to wish fervently that Wyeth would go away. For the first time, I really began to understand the man.

And he understood, too, evidently, for he slipped on out of the house and drove away.

It is Snowden's voice that possesses you. Hearing him only, as one might on a tape recorder, you would visualize a soft-spoken philosopher or perhaps an erudite psychiatrist, not a withering unshaven Negro whose muscular and mental coordination is not quite what it once was.

His voice is warm honey, flowing softly and easily around harsh Anglo-Saxon consonants, fooling the listener into thinking he is hearing grandiloquent wisdom. But the words, shorn of the sound, contain only half-meanings. So wonderfully fluid is that voice, so gentle, that even Willard's blasphemies sound like prayers. "Jesus Christ, but it's cold out there," he remarks, looking out the window. A man with a voice like that could curse in church, and the congregation would utter "Amen."

Willard took care of Andy's studio, and the people who came prying in. If, at the same time, he was himself taken care of, there was no conscious thought of charity involved on either side. Willard made, in my opinion, the perfect receptionist. He was ready to talk on any subject, to satisfy the most questing mind, without really saying much at all; he would so unsettle the merely curious by the clash between his voice and his body that they moved on their way quickly. And he was smarter than you thought he was after you thought he was more stupid than he first appeared to be.

The telephone is the worst part of his job. When it rings, Willard gets a pained look on his face and sighs. The longer the ringing continues, the deeper the lines of suffering etch themselves into his face, and the longer are the pauses between his words. If the phone stops ringing, he brightens up immediately.

"Sometimes I have to answer it though," he admitted sadly. "From the *Farm Journal,* you say?" he began again. "I know your magazine. Yes. I'm just a country boy myself, you know." The unction in his voice was so syrupy that I thought he was trying to humor me. I've heard a hundred businessmen say that, in the same way. "I'm just a country boy myself, you know."

But Snowden really meant it. It was only his voice fooling me. "I work on a farm, you know, in the summer, down the road. She raises some cattle, not for, well you know, she doesn't *have* to. I'm a mechanic, really. Used to work on Case tractors and then I worked on De Laval milkers, too, you know. You ever use them? You from around here? Say, how about you having a drink of wine?"

He went to the cupboard, pulled down a bottle, poured me a glass.

"Don't you want some, too?" I asked, sipping. The stuff was dreadful.

He shook his head, and looked out the window. "Damn, I let him get away without asking him to bring me a beer. That's what I'd like now. A beer. Mr. Wyeth is pretty good about that, you know."

"About what?"

"About bringing me a beer."

"How about if I get you some beer?"

"*Would* you? I'll get us some sandwiches made up and we'll have a nice little lunch." He headed for the cupboard.

"My car's parked way down the road, Willard. It would take me a long time and I'm not hungry yet. You've traveled all over the world, haven't you?"

He sat down again and skipped with apparent lack of interest through the story of his travels in the armed forces. He had been to Europe, South America, Canada, the Orient, he said. He had gone to school in the Navy and learned how to be a mechanic. But he did not volunteer any stories or details of his travels, encouraging as I tried to be. He seemed to feel there was little of importance in his past.

"I hope you're still thinking about that beer," he broke off abruptly, a sly grin on his face. I smiled, but before I could answer, he asked me if I was married. I nodded.

"I was married too," he said, a trace of sadness showing through his casual manner. "I guess I wasn't really good enough for her." His shrug dismissed the subject as he fingered a little brass cannon on the table.

"Those yours?" I asked, indicating the cannon and the toy soldiers.

"Jamie's. Say, it's a wonder he isn't here this afternoon. He just got married not so long ago, you know. She's a nice girl.

They are all nice people, and they treat me like I was, well, you know what I mean, they just treat me fine. You know that is the thing about traveling to another country. Once you're over there and you look back at the United States, well, you understand what I mean. I don't think, well, Christ Almighty, I don't go for this marching and demonstrating, you understand. They wouldn't like to hear me say that, would they? My father was a strict man and he brought us up strict, like, you know, you have to work for what you get and try to get along."

"How did you start working for Andy?"

"Well, I was out of work, and I went to Miss Carolyn, at the big house, and told her I was out of work, just temporary, you understand, just a couple of days, and she said, why didn't I go talk to her brother? So I did. He put me to work down at the mill, carrying lumber around. It was pretty hard on me. One day Mr. Wyeth came over and asked me would I like to work with him painting. Well, I didn't know anything about it much, you know, but I decided to give it a try and I came down here and Mr. Wyeth and me have been doing pictures ever since. Sure you don't want a pork sandwich or something?"

"No thanks, Willard. How does it feel to work with a great painter, anyhow?"

"Oh, it doesn't feel like anything in particular, I guess you'd say. I mean, here, you're a man, and I'm a man and Mr. Wyeth is a man. I mean I'm no different from you, you know, just because I work with Mr. Wyeth. You understand what I mean. What I'm saying is that he is a good man to work for and treats me fine, but I don't feel, so . . . so . . . you know. . . .

"Christ Almighty, everybody thinks of an artist as, you know what I mean, all up in the air, he got cobwebs all around him and cobwebs in his brain, you know what I mean. But Mr.

Wyeth, now, he isn't anything like that at all. And he's almost always pleasant, even when we are working a long time, you know, sometimes eight, nine hours and he will set me at ease with a funny little story, or remark about something I might be interested in. He keeps a little chatter going. But *he* says *I* keep talking most of the time. We're working on a few things now. Hard telling what will come of it. He works nights, sometimes right on through a weekend. That is all he does. Walks and paints. You want some more wine? How about an apple? Or some potato chips? If you go get that beer, I'll fix us some supper."

I protested my full stomach. Willard kept talking.

"He doesn't much bother about the way a man looks. Take a look at that old coat over there. Hanging on the hook there. The one with the horse-blanket pins holding it together. Well, he wore that till it fell apart and kept on wearing it. He don't care about that, you know. One time Miss Carolyn and Mr. Wyeth were going to some art show in West Chester and they asked me to ride along. So I did. Then they said come on in to the show, but I didn't want to, you know. I wasn't dressed for it at all. I just had some old clothes on and I said no, I didn't want to go in, but, you know, they just made me go in there, me looking like a farmer just off a tractor in there with those tuxedos and things. It embarrassed me, it did. And those fancy people too, I wouldn't wonder. But Mr. Wyeth and Miss Carolyn, they never worry about such things."

We talked on, and Willard was repeating himself. He'd lapse back into navy days, jump forward to artists who didn't have cobwebs in their heads, hinted for beer, lulled me to dullness with his voice. He beat me at my own game, perhaps without knowing it. But once in a while he would tell me something, then pause, look sharply into my eyes, and say,

"That is not for publication." And some of the mellowness in his voice wouldn't be there. I would look hurt then, not because of his statement, but because I hadn't completely removed the stigma of the reporter that lurked between us.

So I will not repeat those anecdotes though they are harmless. Willard is angry enough at me already. I never did get his beer.

I went away without answers to the questions that needled me. Or perhaps I found the only answer. Why did Wyeth paint Willard Snowden? Who *was* Willard Snowden?

Was he a man or the shell of a man?

Was he a Negro, or the shell of a Negro?

Was he an alcoholic or the shell of an alcoholic?

Wyeth painted Willard Snowden because Willard Snowden was there, that's why. That is the only answer. Look at the paintings and quit asking dumb questions.

"Mr. Wyeth, he never worries about such things."

"WYETH IS *OUR* ARTIST"

I had followed Wyeth's prog-
ress for nearly twenty years. By now I felt I should be able to
deliver some shattering evidence to explain his popularity,
some penetrating insight that had escaped the puzzled art
critics. Not so. What I had learned about Wyeth's paintings
seemed hardly more than what I had known instinctively
back in the early years on our Ohio farm. I felt defeated.

Whenever I did try to explain Wyeth, I found myself re-
membering my mother driving a team of horses and a corn
binder down rows of ripe corn. She was singing to soothe my
brother, just a baby, sleeping in a wooden box bolted to the
tongue of the binder in front of her. I was astride one of
the horses, the sweat of its heaving flanks sticky on my bare
legs. That was 1940 and Wyeth was just beginning to find his
way. But I *know* that the reason for his fame was building
right then in my marrow and in that of all the people like me,
though we did not know Wyeth existed and couldn't have
cared less.

But to explain a simple truth like that in the world of words
and typewriters is not so simple. In the world of words, men
are paid to make simple things complicated. I faltered. What

Forrest Wall and I could communicate by a glance, I lacked the talent to make an art critic understand in a dozen pages of words. Corn binders and typewriters did not mix.

So I went back to the beginning. Back home, where North was anything beyond the walnut tree on the pike and South still meant turning left at the second orchard. Back where Wyeth had been the first painter we ever cared about. There would be no work horses left now, no babies cradled on corn binder tongues. Would there be Wyeth people still?

I sent the manuscript of the foregoing chapters to a woman who had put her home and her roots down on the pasture-land where she and I had raced barefoot twenty years ago. My sister Jenny had found no reason strong enough to seek other worlds. I asked her to read what I had written and be ready to talk. A week later, I went to visit her.

There are certain signs by which you can identify an old farmstead. As I approached this one, I noticed some of them: a lone lilac bush (next to where the kitchen doorstep used to be); a huge old pine tree—in an area where pine trees do not grow naturally, planted by some bygone pioneer farmer to "turn away lightning from the house"; two old apple trees; hollyhocks along the no-longer wall of a privy or smokehouse or chicken coop; peonies by a picket fence; and lilies of the valley in the north shade of the house foundation.

She was waiting at the door.

I stood for a moment in the house yard. "It's so quiet," I said.

"People always say that when they come from the city," she replied. "Wait till the tractors come rumbling down the road. Not so quiet then."

I followed her into the kitchen. "You can just sit there if you want to," she said, "and I'll keep on ironing. The kids are both asleep . . . these are precious moments."

She picked up the iron. I sat down. That first difficult moment. "You told me once," I began, "that you were surprised Wyeth has become so famous."

"Yes . . . he paints such simple things. In a way. I look at one of his fence posts, and I like it. I say, just leave it at that."

"And I should leave Andy alone, too?"

"I can hardly say that. But I feel sorry for him. It must be so oppressive. The publicity. I watched him on TV, at the White House. He didn't look like he was enjoying himself very much. I remember several years ago on TV he was asked to talk, and he got up and said he didn't have anything to say. That's when I decided I would like him as well as his paintings. Just think. Someone wise enough to admit he had nothing worthwhile to say."

I told her how Wyeth tries his best to keep from publicity without being rude. "He once said to me that reporters writing about his models destroyed his own relationship with them so that he could not paint them again."

She nodded emphatically. "Sure, I understand that exactly. Somebody making a big deal out of it. Just ruins the whole thing."

"So I shouldn't write this book—about Wyeth people for Wyeth people?"

"I'm just giving you what my point of view would be if I were the artist. There's another side to the argument. Wyeth has fame now, fortunately in one way, but unfortunately in another. He's going to have to live through it. He will have to become more secretive though, to stay one jump ahead of publicity."

Silence. Only the hissing of the iron.

"I think I know what you are trying to do," she continued. "You want to make a big thing out of creative genius. But there are hundreds of artists working every day. Only a few

of them become famous or popular. But when the artist finally *is* famous, the historians and art experts study his works, the paintings themselves. They try to find reasons for greatness in the paintings when maybe the reasons are in the painter and the painted. Maybe this one painter, or these few, lucked out and unwittingly painted what many people afterward decided to like.

"After I read your manuscript, all the next day I kept thinking about it. I had this very odd feeling that I knew personally these people you wrote about—the ones Wyeth painted. I found myself more intrigued by them than by Wyeth. And then I got this devastating idea. Which is more important, really: Andrew Wyeth or his models?"

She shifted her thoughts: "I've never seen an original Wyeth painting. Are they better than these prints I have?"

"Yes, I guess." I shifted in my chair. "Everyone always says you miss the force of the painting not seeing it in the original. I suppose they're right. The originals seem to be more imposing; the color is fresher, livelier, or something."

"Thousands and thousands of people, like me, have never seen an original," she countered. "All those who went to his museum exhibits were convinced *before* they saw the originals. What does that mean about art?"

I said I didn't know.

"Well, we—all of us living around here, at least—are the kind that Wyeth paints. What is in his subjects is in us. But we take it for granted. After he paints them we suddenly realize that there are many, many people in America who are like us."

"You discover that you have a culture," I suggested.

"Yes, maybe that's it." She smiled. "A Silent Majority culture. But that tag rankles in me because it lumps us all as

ultra-conservative. A mistake. If it is conservatism we have, it's not the kind that politicians understand.

"It's endurance that we have. Ingrained in our culture is the patience to endure. Each day I stand here and look out my window and watch the seasons pass—life coming, going, coming again. We live every day with this truth. We are the ones who learn to resist change least of all. Is that conservatism? To take comfort in endurance? To know that endurance is better than change? Change runs in circles, repeats itself. We are the rock; the wind blows one way, then another.

"That is why Wyeth is *our* artist. He paints people who have learned this basic lesson of life: to endure. Critics who claim that he paints only the sentimental past miss the point completely. He doesn't just paint the past. He paints endurance. He paints eternity. Or rather each painting shows an instant in time so utterly real it becomes eternal.

"That sounds corny, but that's what I decided I'd tell you. And that's all I have to say on the subject, too. If you have to worry and work for a living every day, you understand what Wyeth says in every painting. We endure!"

INDEX